The Gardens at Giverny

A View of Monet's World by
STEPHEN SHORE

Introduction by
JOHN REWALD

Essays by
GERALD VAN DER KEMP
DANIEL WILDENSTEIN

An Aperture Book

To Ginger

Copyright © 1983 Aperture, a division of Silver Mountain Foundation, Inc.
Photographs © 1983 Stephen Shore; Introduction © 1983 John Rewald;
Essay by Gérald Van Der Kemp, © 1983 Gérald Van Der Kemp;
Essay by Daniel Wildenstein, © 1983 Daniel Wildenstein.
All rights reserved under International and Pan-American Copyright Conventions.
Published by Aperture, a division of Silver Mountain Foundation, Inc.
Distributed in the United States by Viking Penguin, Inc.;
in Canada by Penguin Books Canada Limited, Markham, Ontario;
in the United Kingdom and Europe by Phaidon Press Limited, Oxford;
and in Italy by Idea Books, Milan.
Published simultaneously in a French language edition.
Aperture publishes a periodical, portfolios, and books to communicate
with serious photographers and creative people everywhere. A complete
catalogue will be mailed upon request. Address: Millerton, New York 12546.
Library of Congress No. 83-70828.
ISBN 0-89381-113-0, cloth; ISBN 0-89381-114-9, paper
Design by Wendy Byrne. Composition by David E. Seham Associates, Inc.,
Metuchen, New Jersey. Bound by A. Horowitz & Son, Fairfield, New Jersey.
Separations and printing by Beck Offset Color Co., Pensauken, New Jersey.
Lila Acheson Wallace provided support to the photographer
and for the publication of this book.

The Gardens at Giverny

Introduction

≈ The Ile-de-France must have been one of the most beautiful sections of France before it suffered the humiliation of ugly suburbs and industrialization. Yet the Seine is there, meandering in large loops through the flat lands dotted with forests and fields, with unsightly agglomerations but also with splendid churches. Reverently, the river accommodates an island in the heart of Paris, cradling in its arms the cathedral of Notre Dame. And no sooner has it almost doubled back in its capricious course than it greets the venerable basilica of Saint-Denis, where most of France's kings lie buried. Not far from there it runs under the bridge of Argenteuil, a favorite of the Impressionists, passing the island of La Grande Jatte made famous by Seurat, and then, at Marly, it activates the well-known "machine" built especially to feed the fountains of Versailles, a place the Seine discreetly avoids. This "machine" was painted on several occasions by Sisley who, with his friends Renoir and Monet, used to haunt the bathing and boating spots near Paris. Unlike the parks of Versailles reserved for the court, the Seine belonged to everybody. It also belongs to France's history, winding its way through centuries of its births and deaths.

Once the river passes Saint-Germain-en-Laye (another former royal residence), it enters Normandy, and there the landscape changes. From the terrace of Saint-Germain there unfolds a breathtaking view with Paris in the hazy distance, but now the banks of the Seine become more rural. The fields are carefully cultivated, rolling acres are divided by poplar trees, there are willows, low farmhouses, and some cattle. The villages and small towns are quieter here and set wider apart; soon there will be chalk cliffs along the river, which has patiently washed away the soft stone until it reached its present level, allowing its waters to flow leisurely toward Rouen. On its way the Seine passes many places that—while not actually famous—have a nostalgic ring. There is Conflans where the smaller Oise, leaving Pontoise—so dear to Pissarro—behind, joins the larger river; together they pass Zola's house at Médan where he surrounded himself with friends, among them Cézanne. At Mézy, only a short distance away,

Berthe Morisot had a lovely summer house. After more curves of the river, the twin towers of the cathedral of Mantes appear, which Corot liked to paint; Mantes, that small town jealous of its surname *Mantes-la-Jolie*. After another bend of the river there is Vétheuil where Monet lived with Camille until her untimely death. Behind the houses that almost touch the Seine here, wide and well-trodden steps lead to a quaint old church that dominates the valley with detachment and undisguised benevolence. Farther on lies La Roche-Guyon, literally carved out of the cliffs; Pissarro, Cézanne, and Renoir painted there at various times, little disturbed by the ghost of La Reine Blanche, whose ruined castle dominates the town.

As the Seine indulges in another loop, Bonnières and Bennecourt practically face each other across an island that seems to float between them. Zola worked in Bennecourt in his early years, often in the company of Cézanne. Beyond, another tributary throws itself into the Seine, the Epte, which is too modest to claim any distinction other than that it ends its run near Giverny. From there it is not far to Vernon with its sturdy church often painted by Monet as it mirrors itself in the river. Nearby was an old bridge, victim—like most bridges spanning the Seine on the approach to Paris—of either the German advance or the German retreat. They are all gone. And gone with them are many parts of old villages and towns, many streets and churches and chapels that now live only in the memories of those who can still remember them. No matter how serene the valley appears today, it carries the scars of deep wounds and conceals the tombs of countless dead.

After Giverny and Vernon, the Seine flows on to Les Andelys: Le Petit Andely on the bank of the river, where Signac painted in his youth, and above it, the charming Grand Andely, where Poussin was born (and which was almost totally razed during the last war). Eventually, the Seine reaches Rouen, capital of Normandy, once a jewel that attracted painters from Corot and Boudin to Pissarro and Monet. The richly textured Gothic cathedral on whose majestic façade Monet watched the play of light from dawn to dusk miraculously escaped destruction during years of bombings, but between its delicate structure and the river nothing remains

of the bustling old quarters that Pissarro delighted to paint. It was in Rouen that Joan of Arc perished at the stake, that Flaubert lived, and that Madame Bovary sinned. Beyond the city, the Seine reaches its large estuary which extends from Le Havre to Honfleur. It was in Le Havre that Monet grew up, it was on the beach of nearby Sainte-Adresse that he spent his vacations with his family, and it was in Le Havre as well as in Honfleur that Boudin and Jongkind initiated him into the mysteries of painting. Where the Seine flows into the Atlantic, Monet first felt the call of art.

Between Paris and the Atlantic there was not a spot that was not familiar to Monet. This was his country, not because he was raised there, but because he had taken possession of it as it had taken possession of him. Here the light was soft and nature was radiant, the skies were high and when they were not blue they glistened with pearly grays. The Seine was continuously alive, busy with ships and boats in the summer, carrying ice floes in the winter; always, on sunny days, its waters were vibrant with reflections. This was a garden of Eden from which not even material misery or the anguish over Camille's fatal illness could drive him. Monet belonged to this country. With all the suffering it inflicted upon him, he also owed it his finest days when, as he stood before his easel, it inspired him to execute his most splendid works.

Strangely enough, this fertile Eden also boasts two other, man-made gardens. The first, larger and more famous, is that of Versailles, where a powerful monarch, bent on the most refined pleasures, had laid out for his enjoyment a dazzling park where, as in a Persian rug, flower beds of endless variations formed harmonious arabesques of the most intricate design. Amid these sparkling blossoms stood lovely goddesses of stone offering their elegant bodies to wind, sun, and rain, while delicate sprays of fountains undulated in the breeze. There was nothing like it anywhere. No effort had been spared to make this a spectacle such as nature alone could not even imagine unless she was helped by the inventions of a Le Nôtre and the complicity of countless gardeners.

But this was not the kind of garden that appealed to Monet. It was too manicured, too strict in the symmetry of its floral arrangements, too restrictive in its use of plants for decorative purposes. In a word, it was too dependent on the hand, evident everywhere, that guided nature. If Monet ever dreamed of a garden, which he probably did, since there were small patches even in the most modest dwellings he successively occupied along the Seine, in no way would it resemble that of Versailles.

For years, Monet had been living in various places on or near the river, where the quarters were not too cramped and the rent was cheap. During Camille's final illness, Alice Hoschedé with her six children came to stay with him in Vétheuil to help care for the young woman and look after the couple's two little boys. They remained in Vétheuil after Camille's death in 1879 until difficulties with the landlord forced them to move. It was then, in 1883, that Monet discovered Giverny, a small community of scattered farms farther down the Seine.

It was a typical rural village surrounded by flatlands that form a wide strip between the river and the, at this point, distant cliffs. There were fields and orchards divided by rarely used lanes that seemed to lose themselves among green acres. Actually, it was not a truly picturesque spot, lacking any distinctive buildings or monuments; it was merely a hamlet where simple people lived, worked the earth, and died quietly and modestly. The Seine provided humidity and the sun the warmth for regular harvests. The region seems to lack something of the peculiar intensity that an earlier generation of painters had found at Barbizon, but then, Monet was not looking for any special effects and had never been attracted to those heroic attitudes of the peasants in which Millet had discovered symbols of man's struggle and union with nature. Monet was satisfied with poplar trees rising into the summer sky, with haystacks squatting on mowed fields in fall or winter, with the banks of the Seine or the old church of Vernon almost directly across the river.

The artist and his family found lodgings in a low, elongated farmhouse with a large

garden. Monet rented it, but as soon as his slowly increasing success permitted, he undertook trips to nearby and even faraway places so as to vary his subjects. Yet he always returned to Giverny, his home. Eventually, he was able to buy the house they occupied and it was then that an almost feverish activity began, to improve the building, to add large studios, to lay out an elaborate garden, and, finally, to create—beyond the garden and on a plot separated from it by the tracks of a rarely used railroad—a pond of water lilies. It took patience and ingenuity as well as a good deal of money to achieve all this, but Monet immersed himself in this labor with the passion of a perfectionist. He had found a new outlet for his creativity: the manipulation of nature, not so much to impose an alien will on her, but rather to provide her with the necessary conditions to set her free. All he asked in exchange was that nature take advantage of the climate, the soil, the water and reward him with a lush burst of blossoms, of leaves, of twigs, of spreading bushes, or climbing vines. And nature outdid herself in her gratitude. The garden became a fantastic and gigantic bouquet of ever-changing aspects, with plants crowding plants, carefully assembled and lovingly disposed so that they would constantly succeed each other, bloom upon bloom in an enchanting variety of colors and shapes. Again, all this was done for the sheer pleasure of one man, but it was done for his creative inspiration, so that his eyes (whose perceptions were eventually to be dimmed by cataracts) could feast on what nature had wrought at his gentle urging. Toward the end of each day, Monet would sit on his terrace and contemplate this display of flowers swaying in the evening breeze, the petals of long-stemmed poppies fluttering to the ground, and the roses releasing their fragrance as the sun went down.

The greatest achievement, however, was to be the pond of water lilies, a feat of design and engineering for which the waters of the little Epte had to be diverted, cleansed of impurities, and then released into the Seine (thus providing the indispensable current, for stagant waters would have defeated the whole undertaking). Monet shaped the shores of the pool, dotted

it with blossoms carefully selected for their colors, ringed it with weeping willows, iris, and bamboo, and crossed it with a Japanese footbridge. Again nature obliged, treating this man-made paradise as though it were one of her own inventions, a setting she had always wanted for her whimsical extravagances.

This time, Monet the accomplished gardener and Monet the aging painter worked as one on the ambitious project, for he planned to set up his easel anywhere around the pool and paint the water lilies from many views and under many different light conditions. It was a unique situation: the artist who had been one of the first to work in the open, to practice *plein-air* painting, to pursue nature into her most secret retreats, now adopted the opposite procedure by prompting nature to offer him the facets he desired. The colors of the floating lilies, the sprouts of the bamboo, the undulations of the willow branches were his to determine, so that they could present him with the pictorial elements he desired. Indeed, the water-lily pond was built especially to provide Monet with an endless series of subjects to which, with an all but obsessional single-mindedness, he devoted the rest of his life.

In his mostly large canvases (often finished in his immense, skylit studio), everything at first sight seems formless, for as shifting light plays over the scene, the eye no longer distinguishes between what is solid and what is reflection. Be it water, mirrored sky, or floating leaves, the subject appears unsubstantial. Not a single brushstroke stoops to the task of defining an object. The picture is a sea of dissolved forms drifting between sky and water. But as the viewer steps back, the process is reversed: what Monet knew was there but had chosen to reduce to flickering spots of pigment coagulates at a given distance into distinct features, into the subject that had been the artist's point of departure.

When Monet died at Giverny in the fall of 1926, the garden and the pool slowly died with him. When I went there for the first time in the late thirties to visit the artist's daughter-in-law, Blanche Hoschedé-Monet, the garden had already lost its many-colored splendor, since

there was no one left to care for it properly; but the pool, somehow, had preserved its idyllic otherworldliness. As long as the waters of the Epte kept running through it, the water lilies continued to bloom as though their master had merely turned his back for a while. And the little old lady, now almost living in the past, spoke of him vivaciously, as though she had barely noticed his absence.

Then came the war and with it years of total neglect. The family fled before the onrush of Hitler's army, trying to save whatever paintings they could. Later, after the French surrender, they returned. They found that the large studio had been hit several times and that there were bullet holes in some of the big water-lily canvases they had been unable to carry to safety. By the time Monet's stepson Jean-Pierre Hoschedé succeeded his sister as caretaker, everything seemed irretrievably lost. Rodents—as undernourished as the local inhabitants—had gnawed away the roots of the plants in and around the pond, the waters had stopped flowing—it was a dried-out, devastated, heartbreaking site. Nothing was left but the memory of past glories and the paintings of Monet, of which quite a few were still in the house and others in the studios, where some of the skylights were broken.

The artist's son Michel had long since moved elsewhere and showed little interest in the property, or even in his father's work. Eventually, he bequeathed both the estate and the canvases still preserved there to the French Academy of Fine Arts; thus an entirely new chapter in the history of Giverny began. Under the untiring guidance of its curator, Gérald Van der Kemp, the slow but meticulous task of restoring Monet's domain—the house, the studios, the gardens, the greenhouse, and, finally, the lily pond—was undertaken. It is a story as magical as that of Snow White; nature has been reawakened and no trace is left of the sad years of slumber, or rather of neglect and even wanton destruction.

That there were many Americans whose generous support made this almost miraculous resurrection possible is a sign not only of the fame that Monet's work now enjoys, but also of

the kind of mystique that surrounded his garden even while he was still alive. Were he to come back, he would find everything as it had been in his day, except that now there are many visitors who parade in awe through his house and slowly walk through his garden and around the pool, never quite knowing where to look first, since exquisite vistas solicit their admiration from all sides. If they are ever to feel close to a great figure of the past, they do so here. These are the rooms where Monet lived and slept, where he worked or received friends, where he wrote letters, paid his bills, read the novels of Zola or Maupassant; this is the kitchen where succulent though unconventional meals were prepared for him, his family, and his guests. And there are still some of the very trees in whose shade he sat while all around him blooms seemed to outdo themselves to please him.

He was not an easy man. He was proud and self-centered, even arrogant on occasion, with the peculiar egotism that is the privilege of genius. He was tight-fisted but could also be extremely generous and willingly give of himself when he believed in a just cause. He was among the first to put in high bids at auctions for the neglected works of his friend Cézanne, among the first, too, to believe in the innocence of Captain Dreyfus when Clemenceau and Zola spoke up for him; he spent a great deal of time raising the money necessary to purchase the famous *Olympia* from Manet's widow so that it would find its place in the Louvre. He carefully selected his friends and shunned the hangers-on who always gravitate toward illustrious personalities. He accepted his fame as something naturally due him and let it go at that; flattery never had the slightest effect on him, unless it was a negative one. Time was too precious to be wasted on formalities or empty ceremonies. Academies and honors never attracted him. In moments of joy, as in moments of grief, he could turn to his garden; the silence of nature spoke to him through her manifold creations. Between the two of them there existed a deep understanding that sustained him in difficult hours. Giverny was his world, unlike any other anywhere, and he was its supreme master.

Now that Giverny has been revived, a new generation of artists swarms to it, both for a profound communion with Monet and to experience the indescribable beauties he left behind. New works of art will be created there, not for the purpose of following in Monet's footsteps (which is impossible), but of deriving a new impetus, attuned to our own time, from the inexhaustible richness that his garden provides. Among these artists is the American photographer Stephen Shore. It seems remarkable—not to say extraordinary—that at no time has his approach to Giverny in any way been touched by Monet's overpowering "presence." He has never tried to duplicate either the views the artist had selected for his canvases or the specific light effects that pervade his works. Stephen Shore simply found at Giverny an exceptionally enticing environment, an unusual richness of colors, and an unending variety of compositional arrangements. These he has explored with his camera, guided not by Monet's examples, but by his own sensitivity, as well as by the desire to take fullest advantage of the possibilites that color photography offers. Among the results are, notably, close-ups of flower beds or of single flowers, trees seen in sharp focus, and vistas of a poetic softness, none of which owe anything to the creator of this domain. And in his larger views, which even include the kitchen garden, there is always a fresh approach, a care for details, and a sensibility for serene moods that can only be obtained with a camera handled by a perfect craftsman. To anyone familiar with Monet's property at Giverny, these photographs offer wonderful glimpses of that enchanted place; to those who have never been there, they will scarcely be less appealing and precious as reflections of nature's abundance and beauty. They are a constant reminder of Lamartine's verse:

Mais la nature est là
Qui t'invite et qui t'aime.

JOHN REWALD

The Gardens

Looking down from a nearby hilltop, across fields and trees south toward the Seine, a visitor sees Monet's house and garden complex, situated at the eastern edge of the Norman village of Giverny (opposite). The long, low pink building with green shutters is the painter's house, where he settled in 1883. His first studio in Giverny, in the western end of the house, was later converted to a sitting room. Sometime around 1899 Monet built his second studio, the two-story pink building, with its slanted slate roof and single skylight, to the west (right) of the main house. The third and largest studio, built in the early years of World War I, was designed specifically for Monet's oversized water-lily canvases. The slanted roof of this large white building has two immense skylights. The formally laid-out Clos Normand garden extends south from the house to a road, across which is the water-lily pond, around which the Water Garden centers. Paris lies upriver on the Seine, to the east (left).

Looking northwest from the Clos Normand, the visitor sees the second studio (page 18) with Monet's greenhouse nearby. From the central path arched with trellises, the main house is visible to the north (page 19 and 21). At the far (south) end of this path is the garden gate; across the road is the gate to the Water Garden (page 23).

Stephen Shore made these photographs on three separate visits to Giverny, in September of 1977, four years later in September of 1981, and in the spring of 1982. The first group, of twelve photographs, was made in 1977 and reflects the gardens during their restoration, much as they must have appeared during Monet's early years at Giverny.

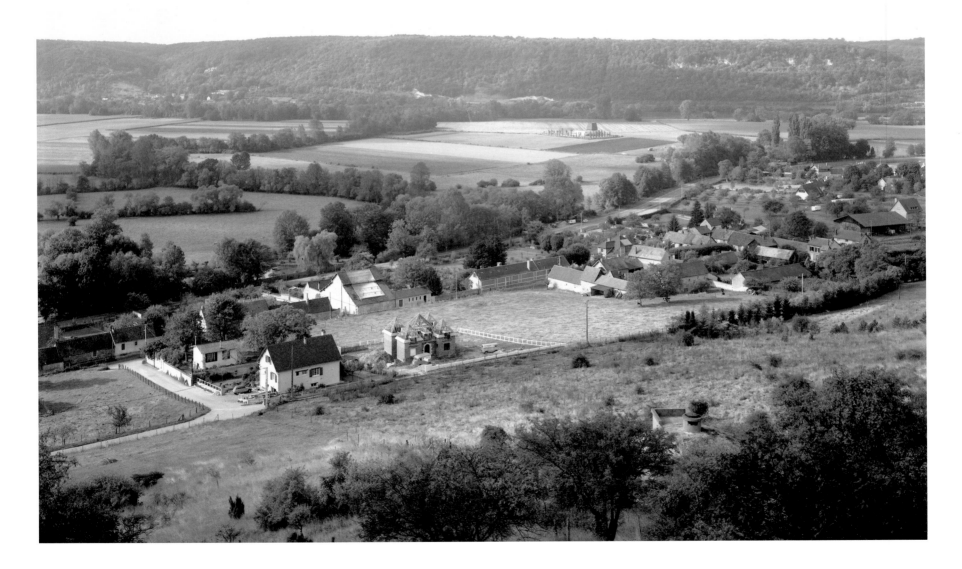

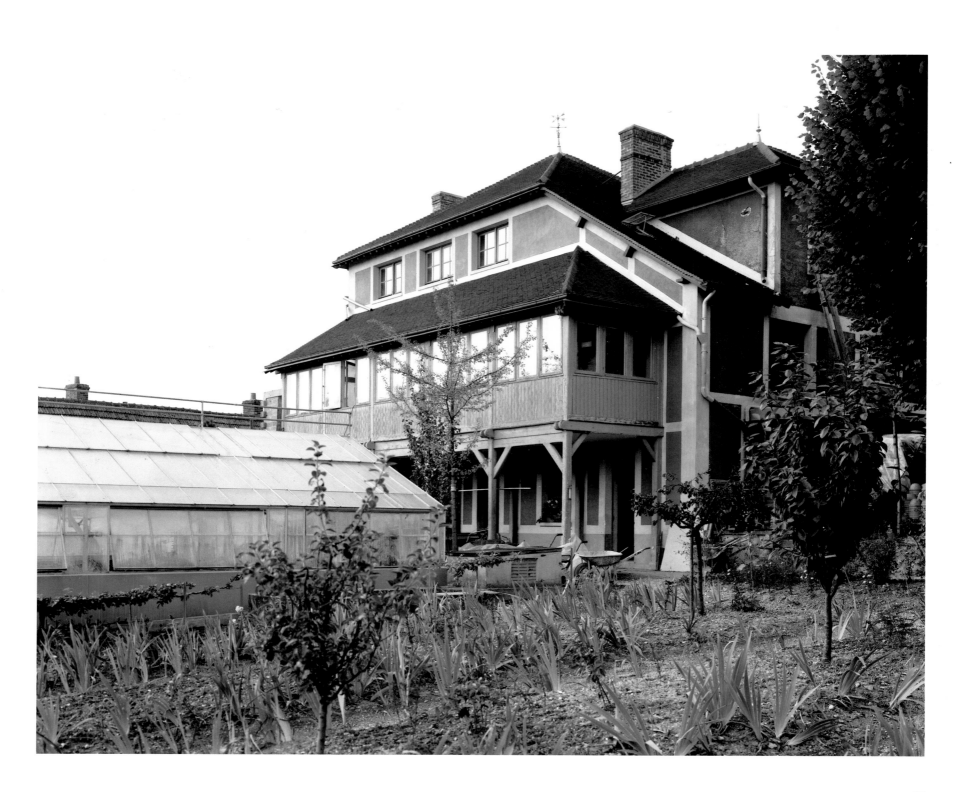

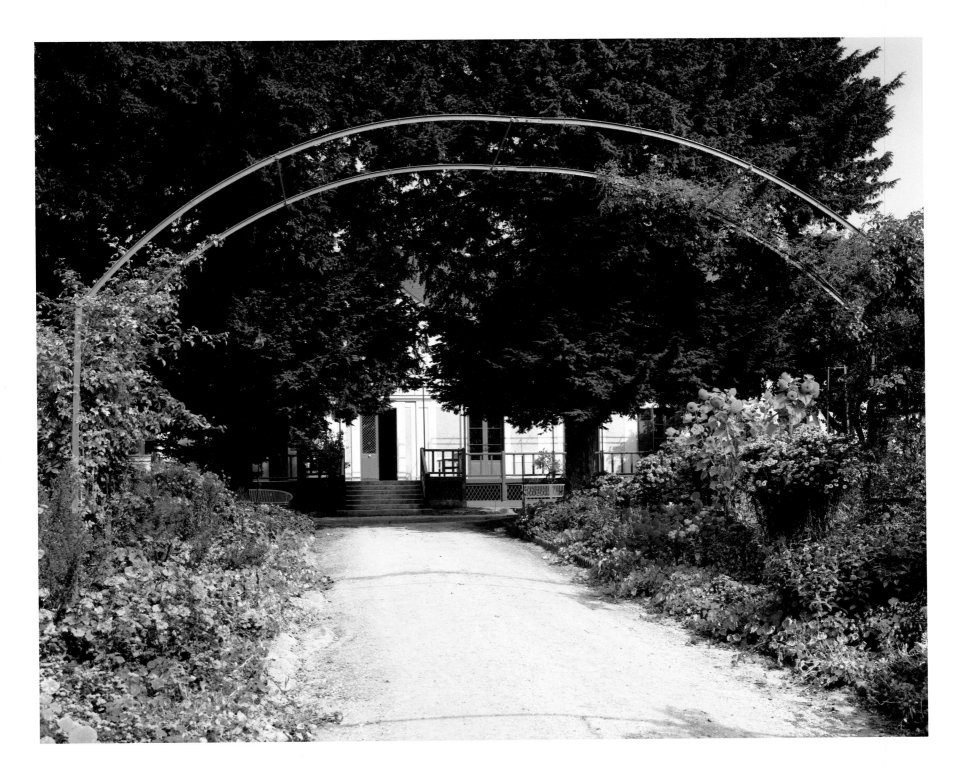

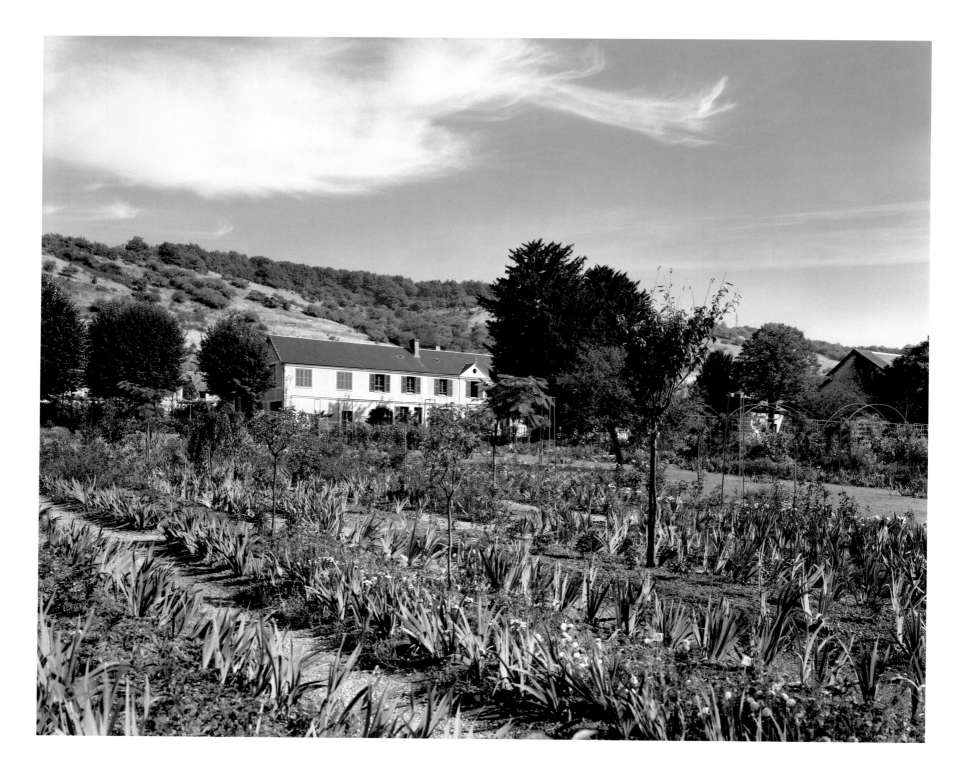

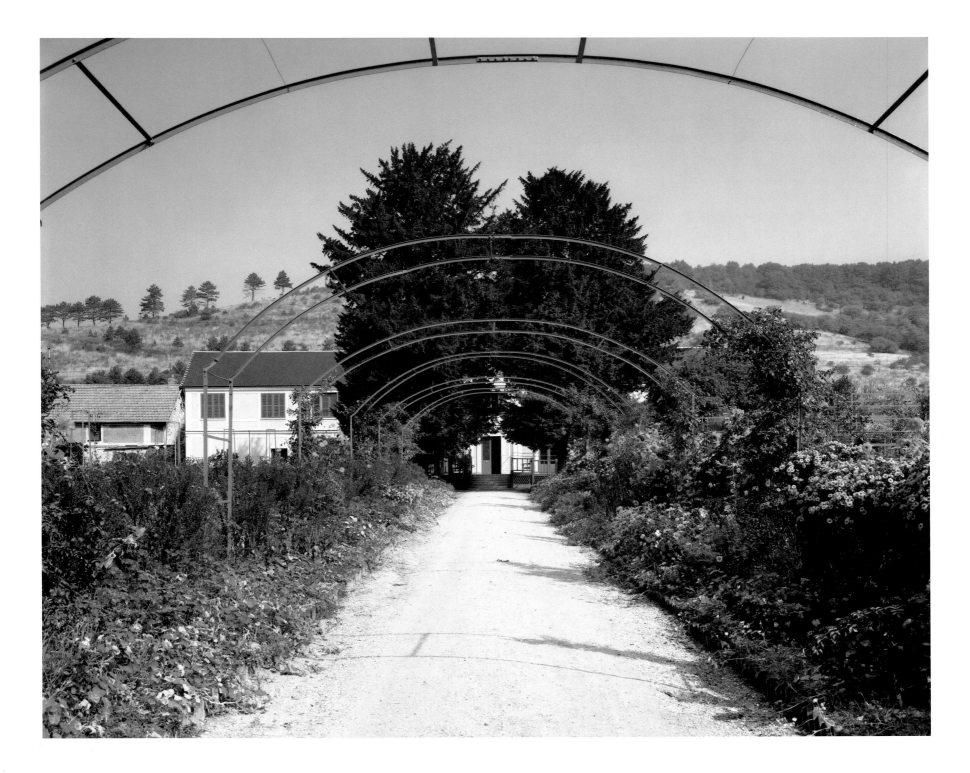

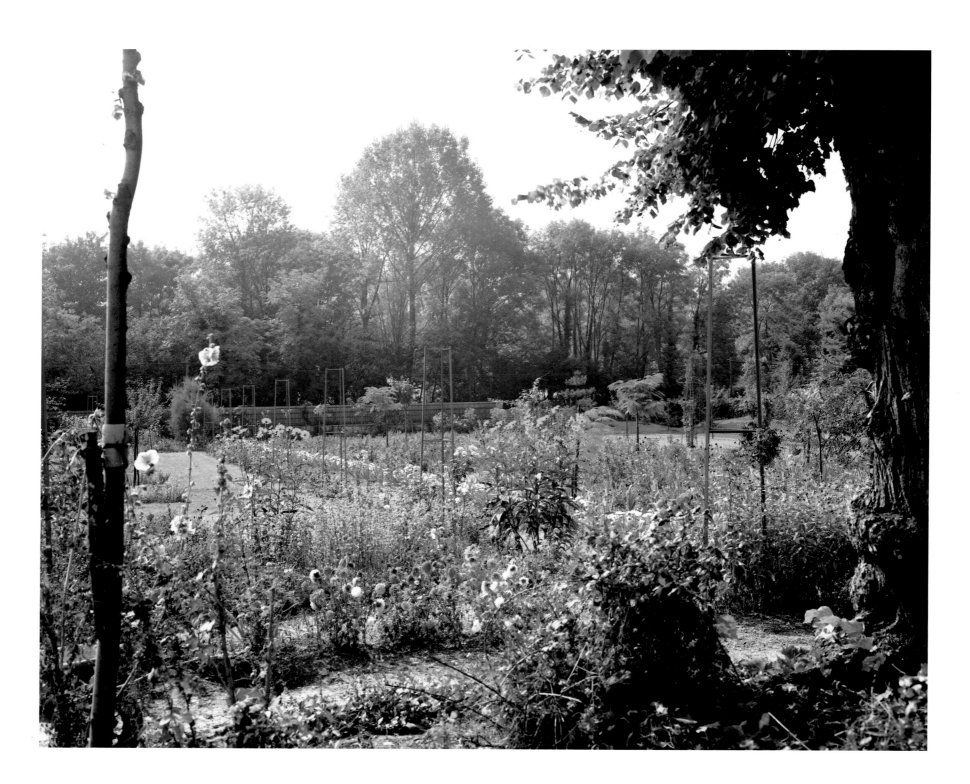

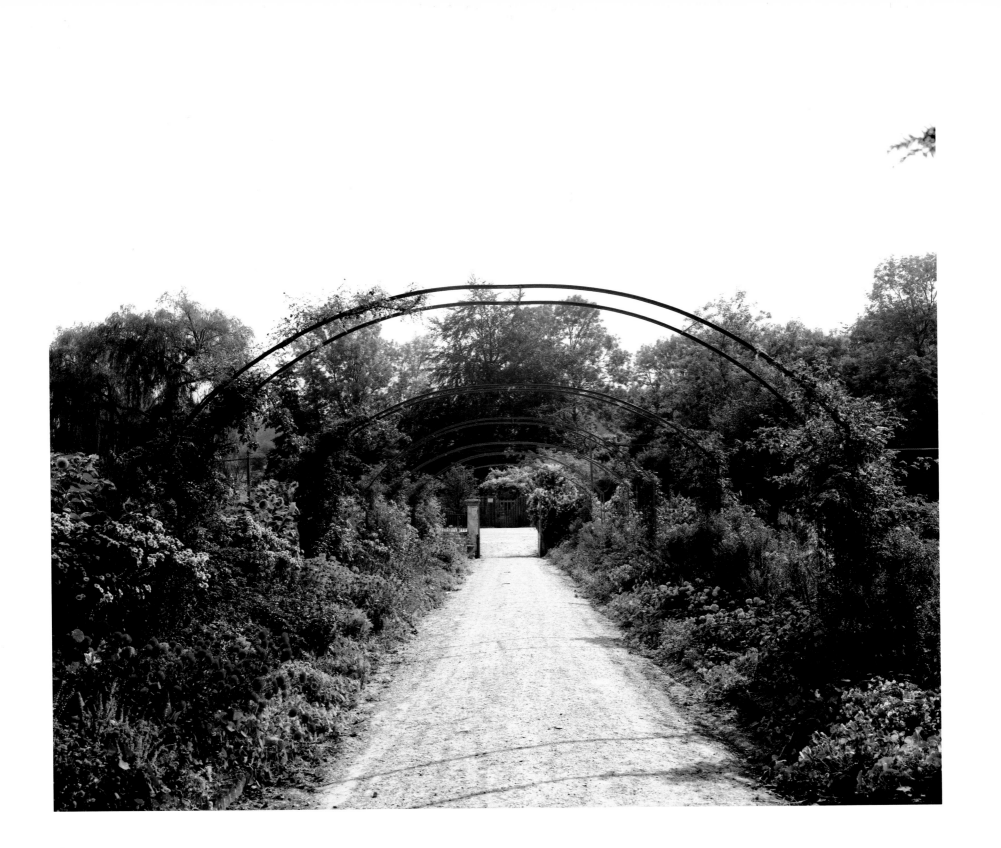

Monet bought the land for the Water Garden in 1893, though the pond itself was not created until two
years later. By building sluicegates and rechanneling water from a tiny creek—the Epte, which in turn runs
into the Seine a few hundred yards away—Monet supplied his newly excavated pond with water. The footbridge
across the pond (opposite and page 27) reflects some of the influence of Japanese art on the great French painter.
The water lilies shown on page 29 are only a hint of what they later became (page 63).

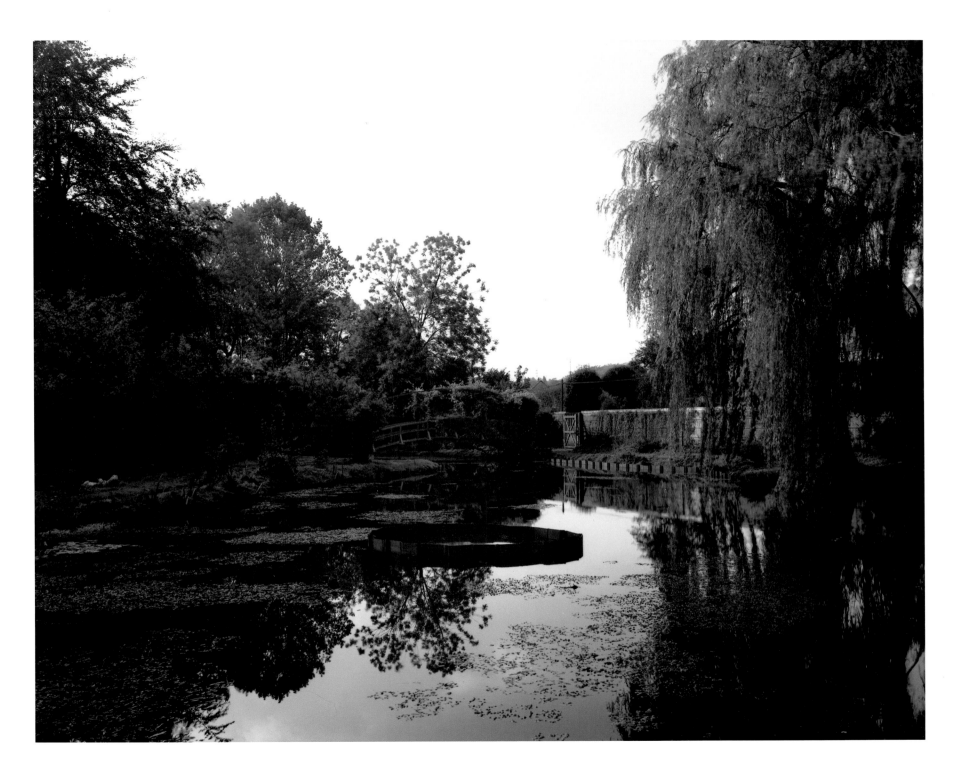

25

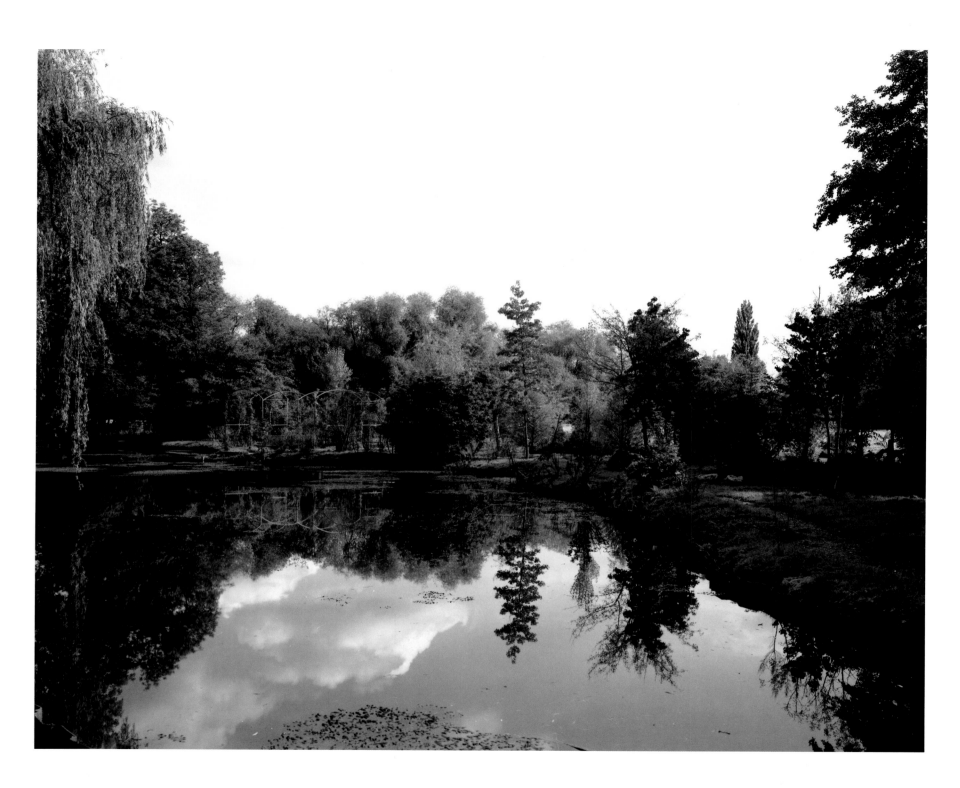

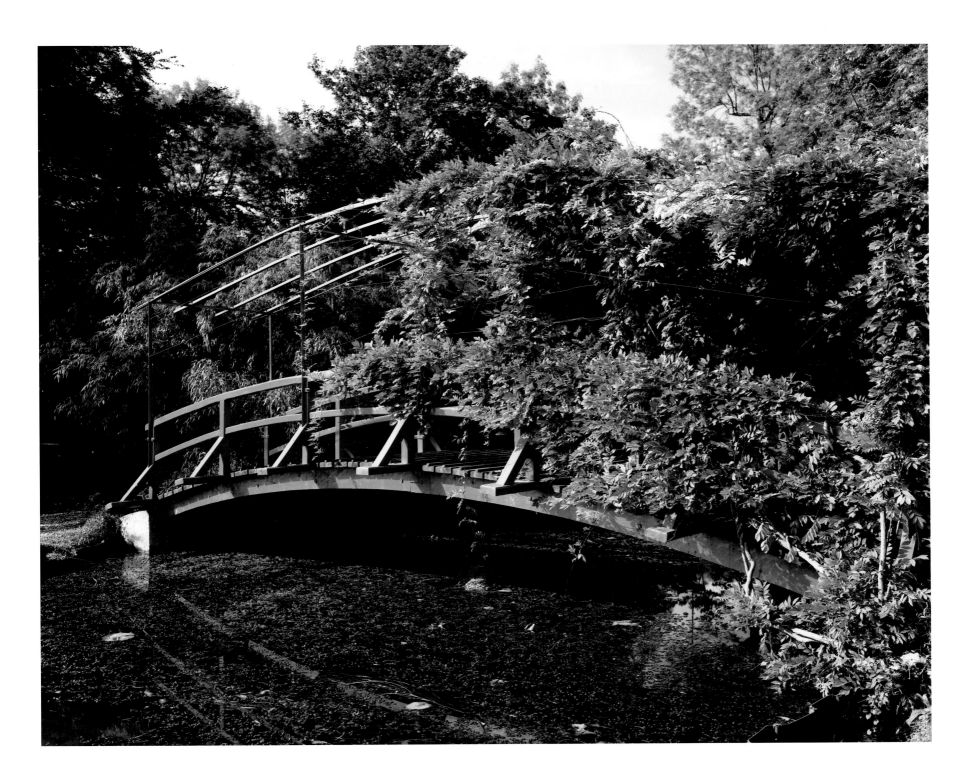

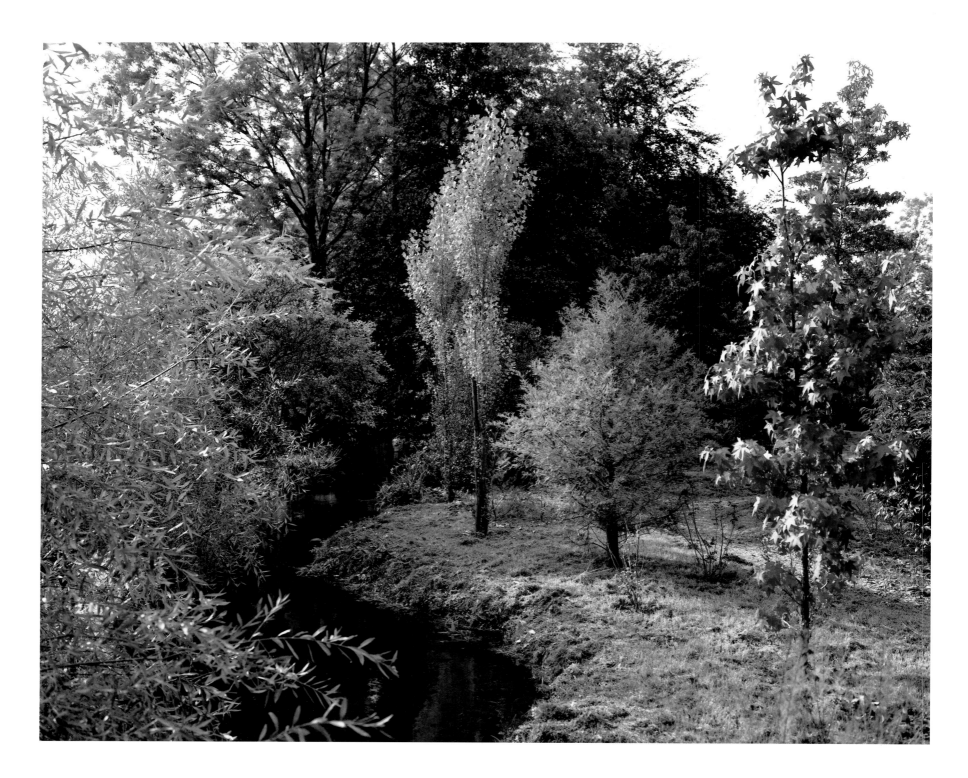

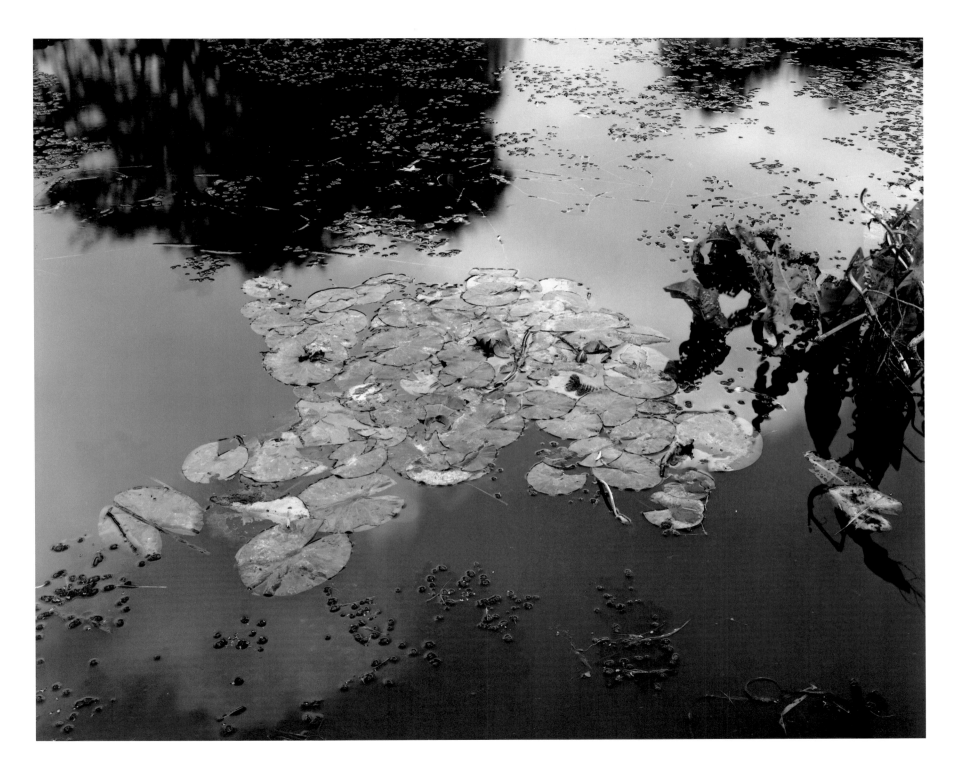

The photographs that follow were made during the fall of 1981 and the spring of 1982, by which time the gardens had been largely restored to the state they were in during Monet's life.

The gardens strike a balance between the presence and absence of the gardener's hand. Certain areas are carefully cultivated (opposite), while others are consciously allowed to grow freely into seemingly overgrown masses of flowers and foliage (pages 35 and 36).

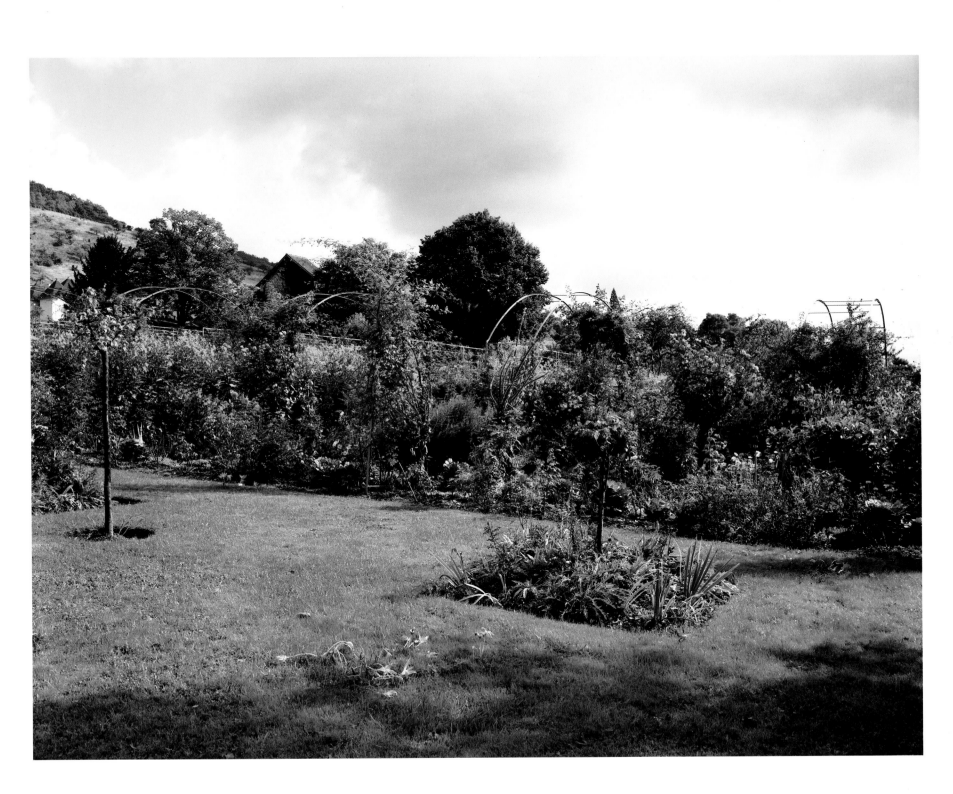

33

Arched trellises for roses span the central path of the Clos Normand, where nasturtiums run wild (opposite). The two yews remain from Monet's time, standing like sentries at the top of the path, guarding the house. Tulips, rhododendrons, zinnias, and asters were among the artist's favorite flowers.

The distinctive pink color of the house—typical of Normandy—results from mixing crushed brick into white stucco to create a pebbled surface. Monet chose the green of the doors, shutters, and porch himself, a green generally used in France for garden furniture.

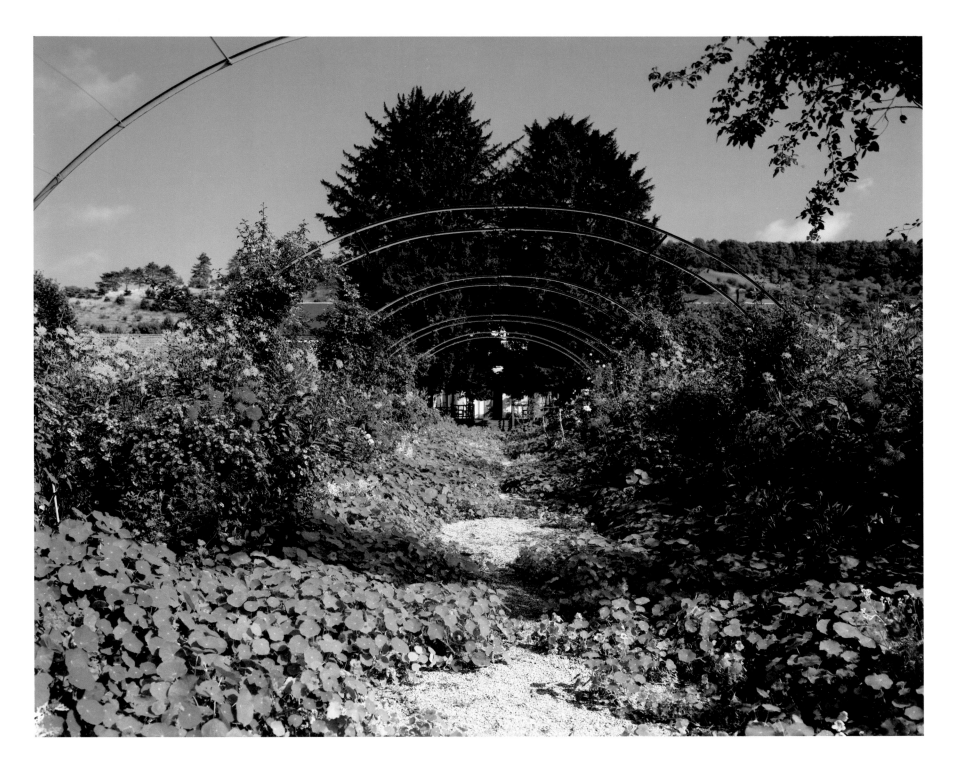

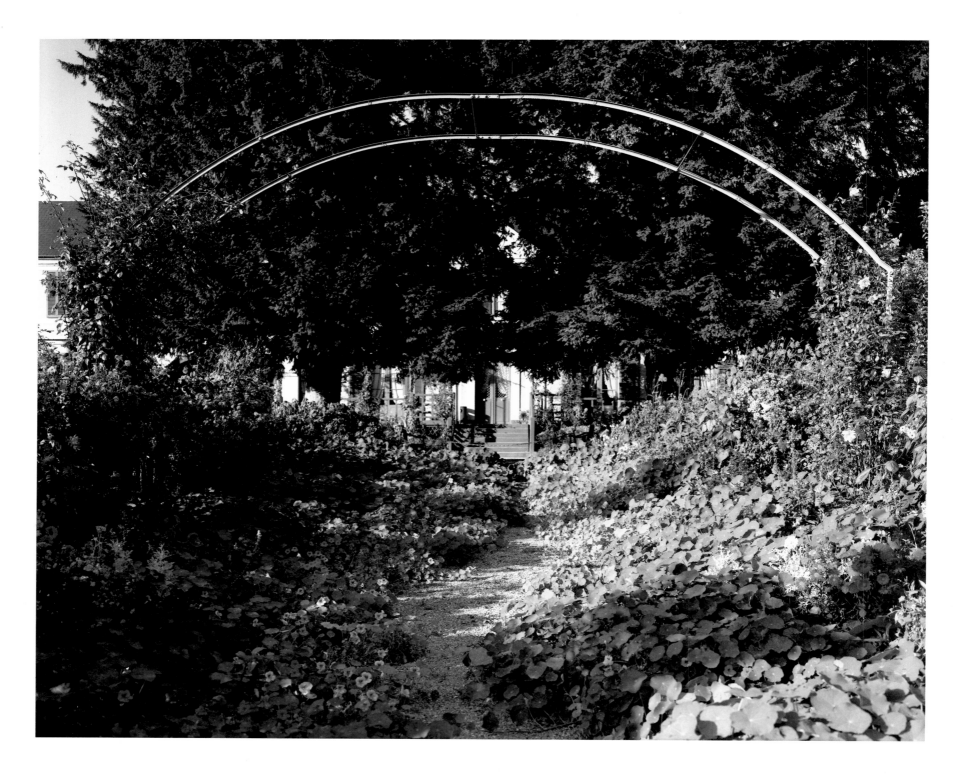

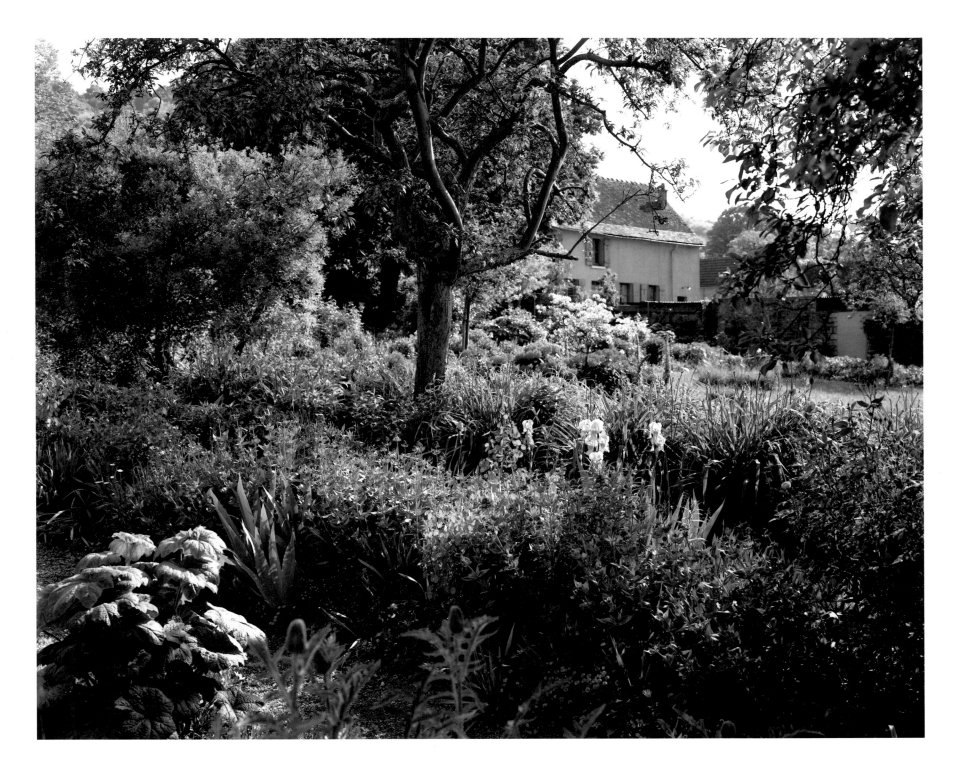

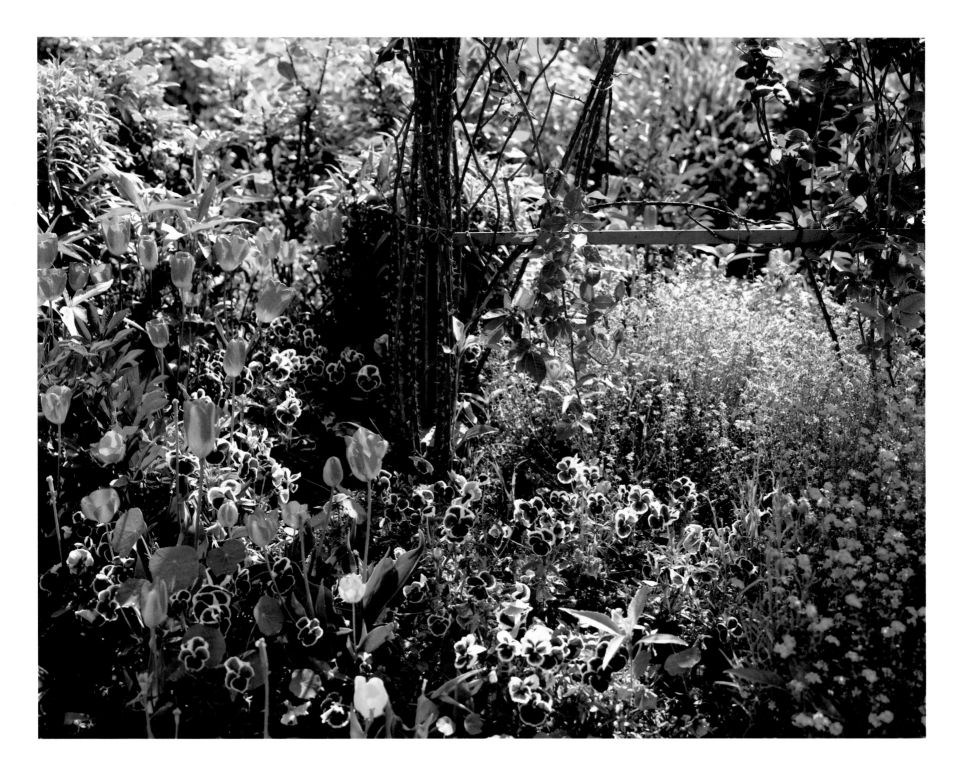

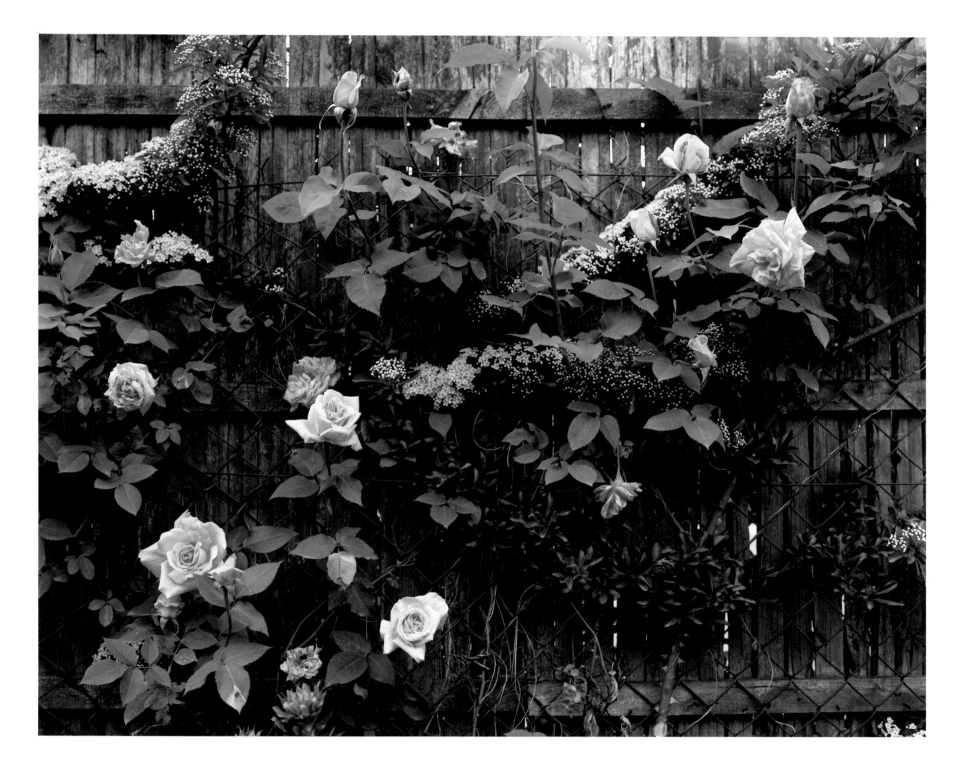

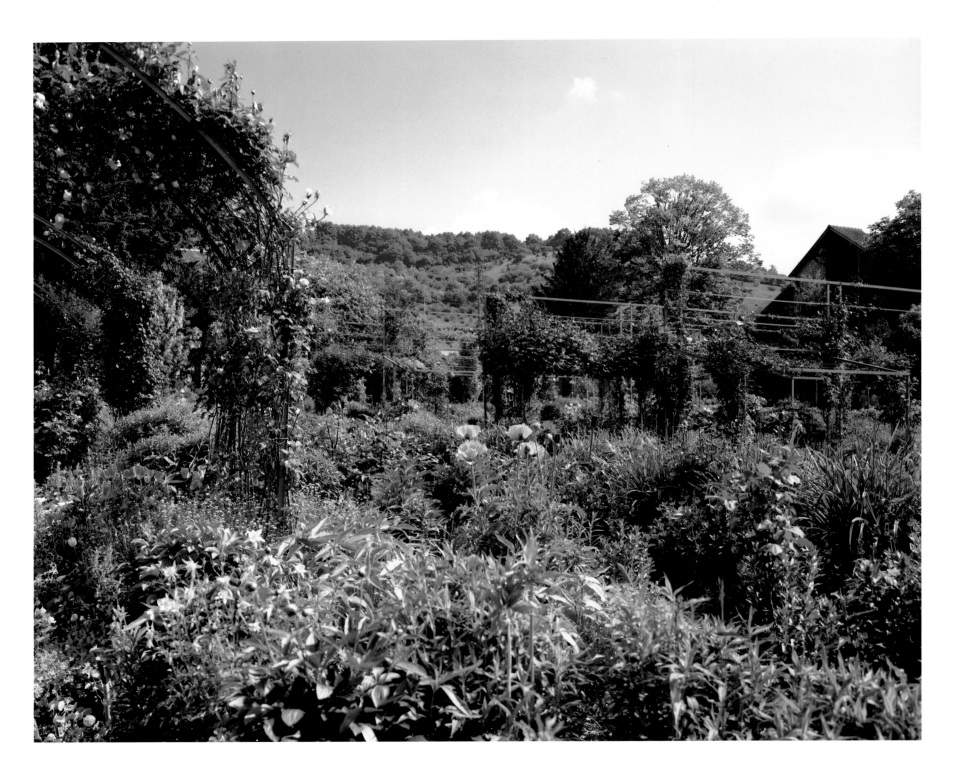

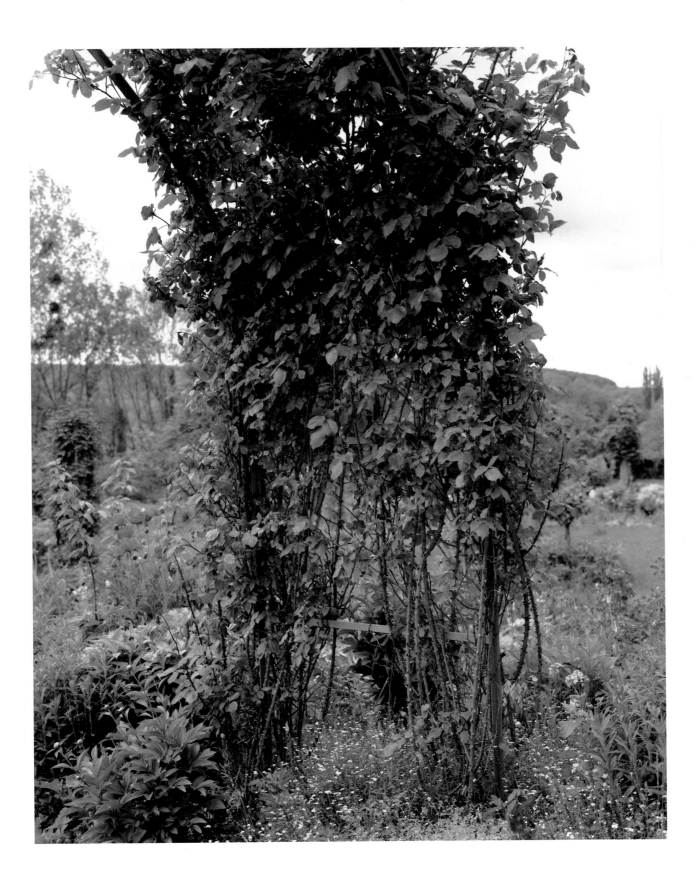

Tulips, pansies, and forget-me-nots crowd the thorny rosebush stems at the foot of the trellises (opposite). Monet particularly loved irises and planted them in long, wide rows (pages 50, 51, and 52).

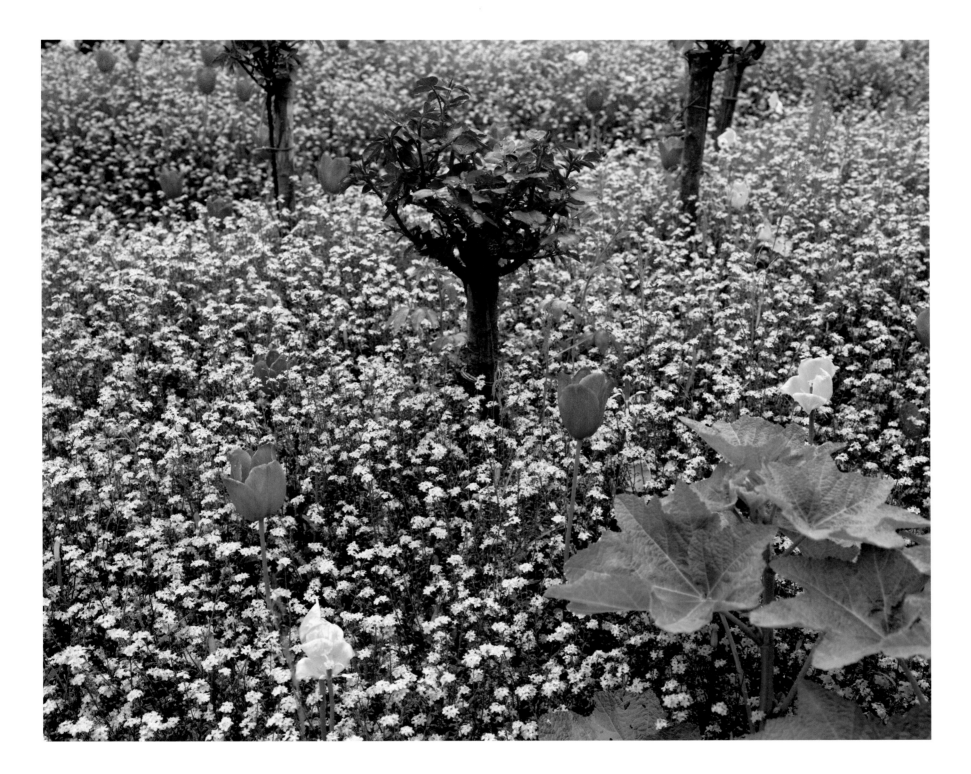

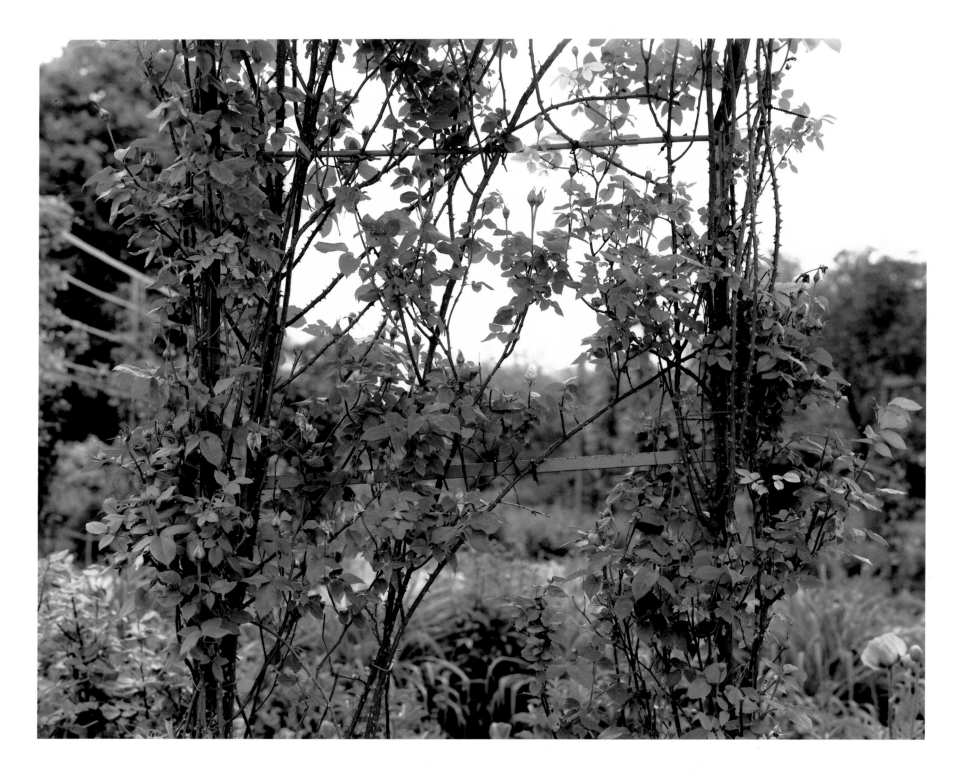

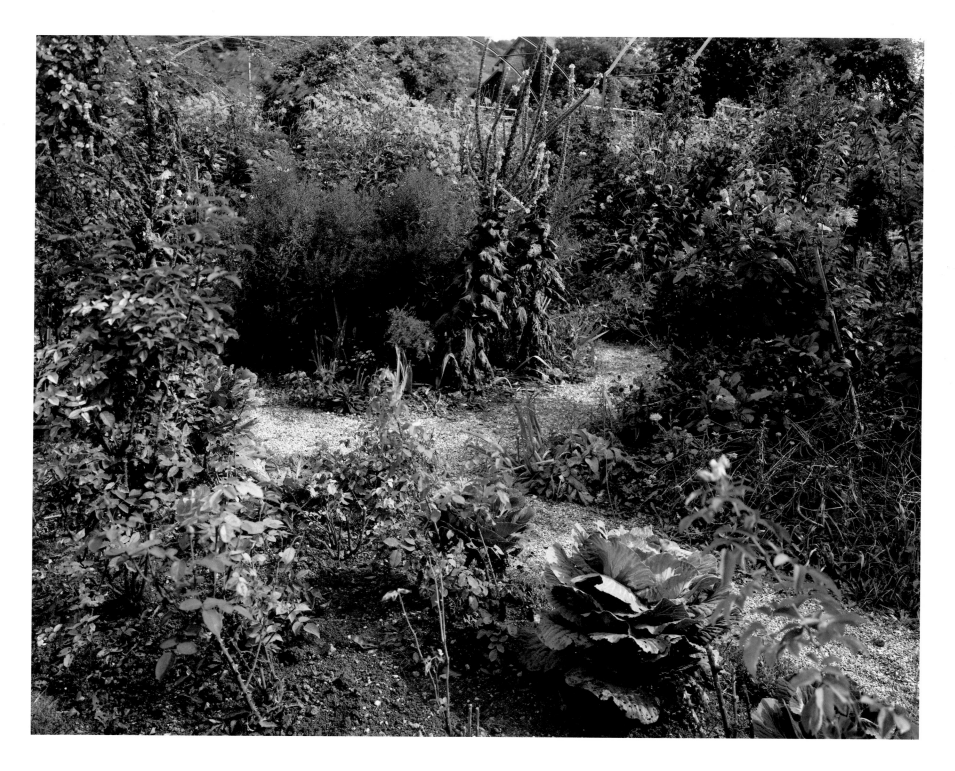

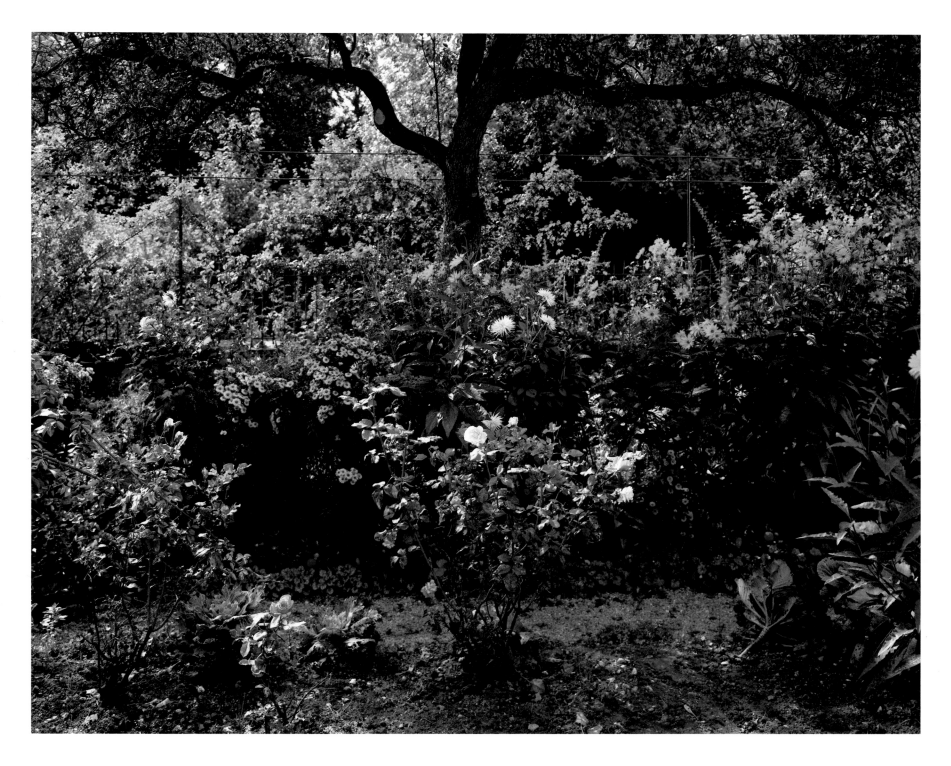

49

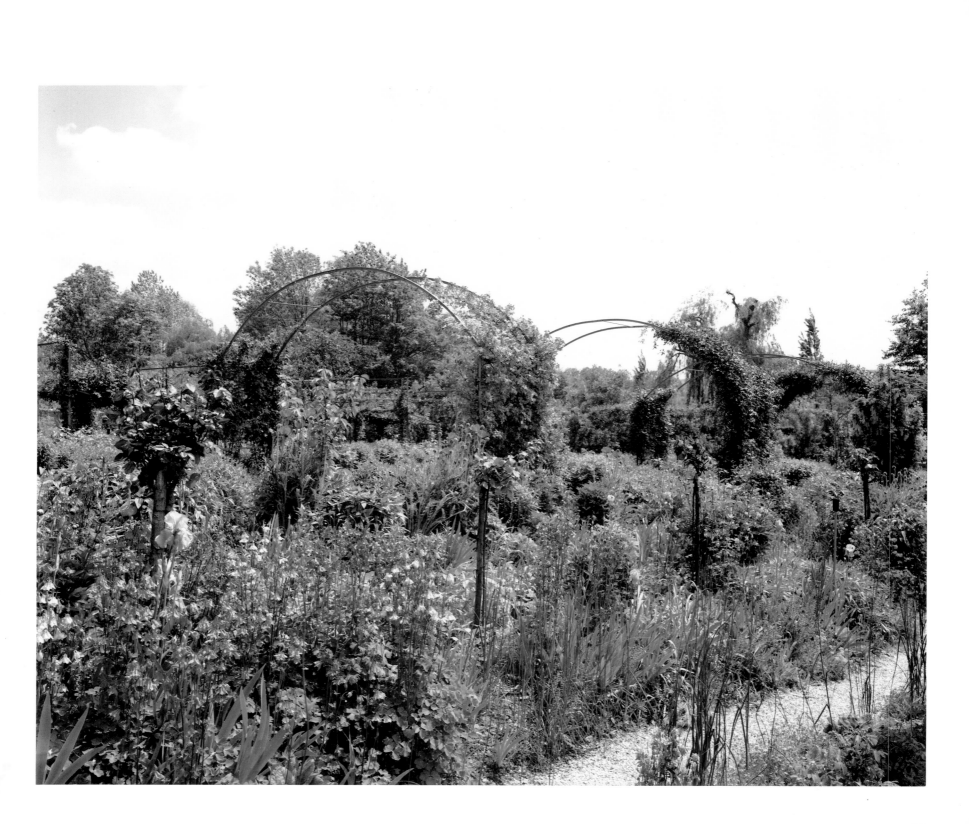

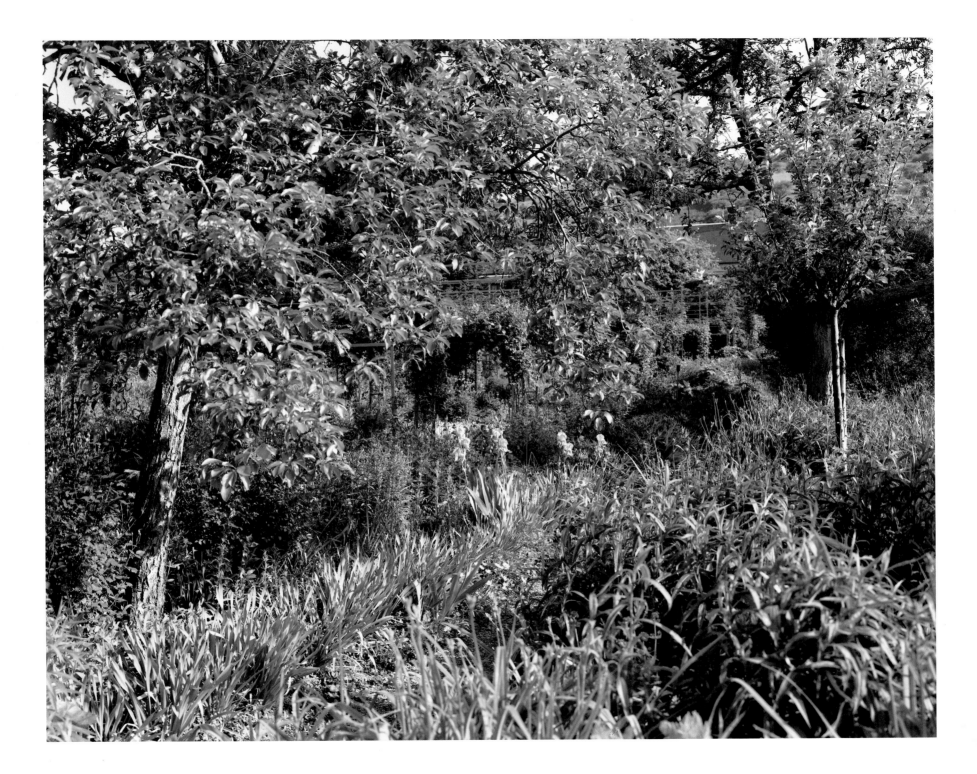

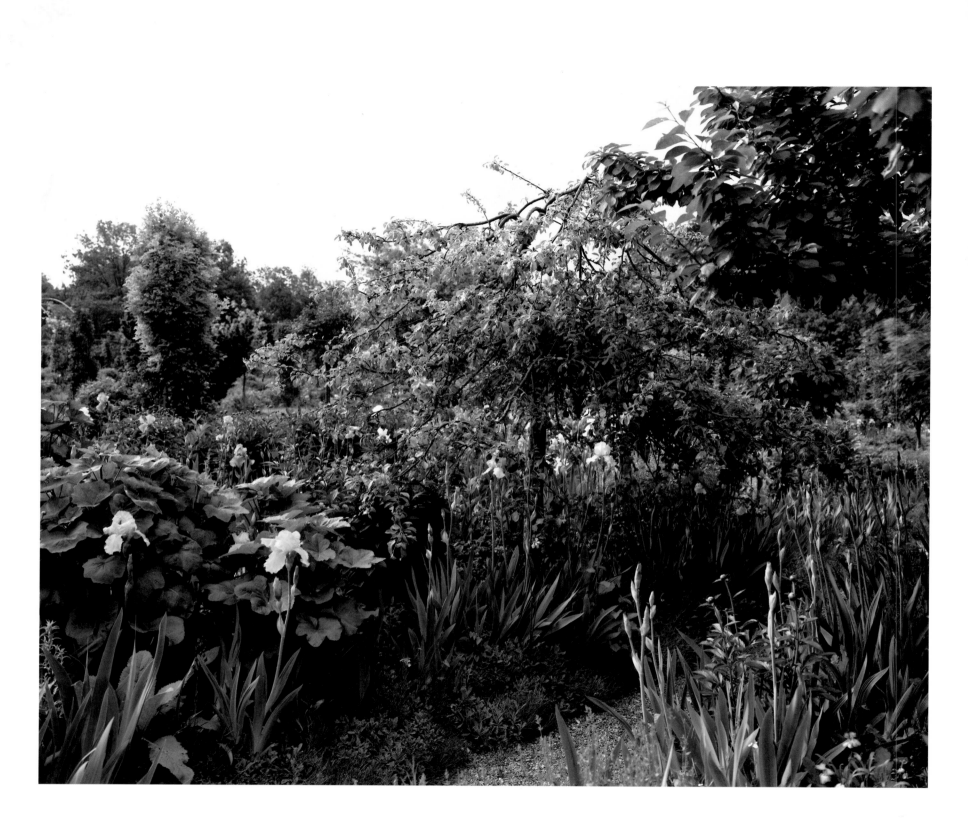

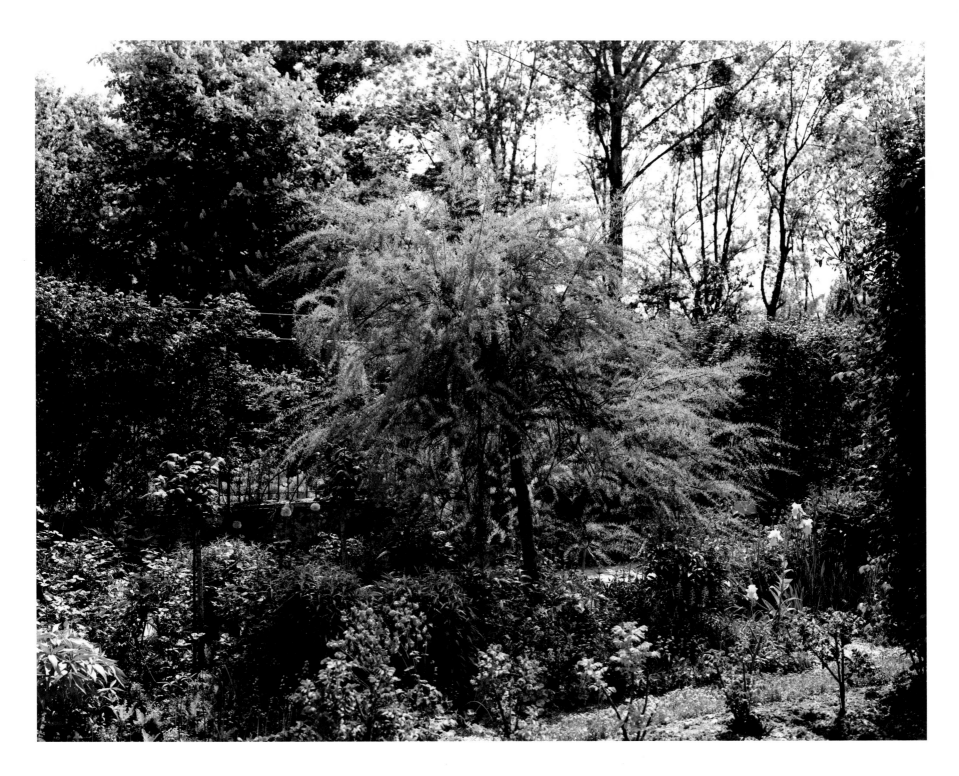

53

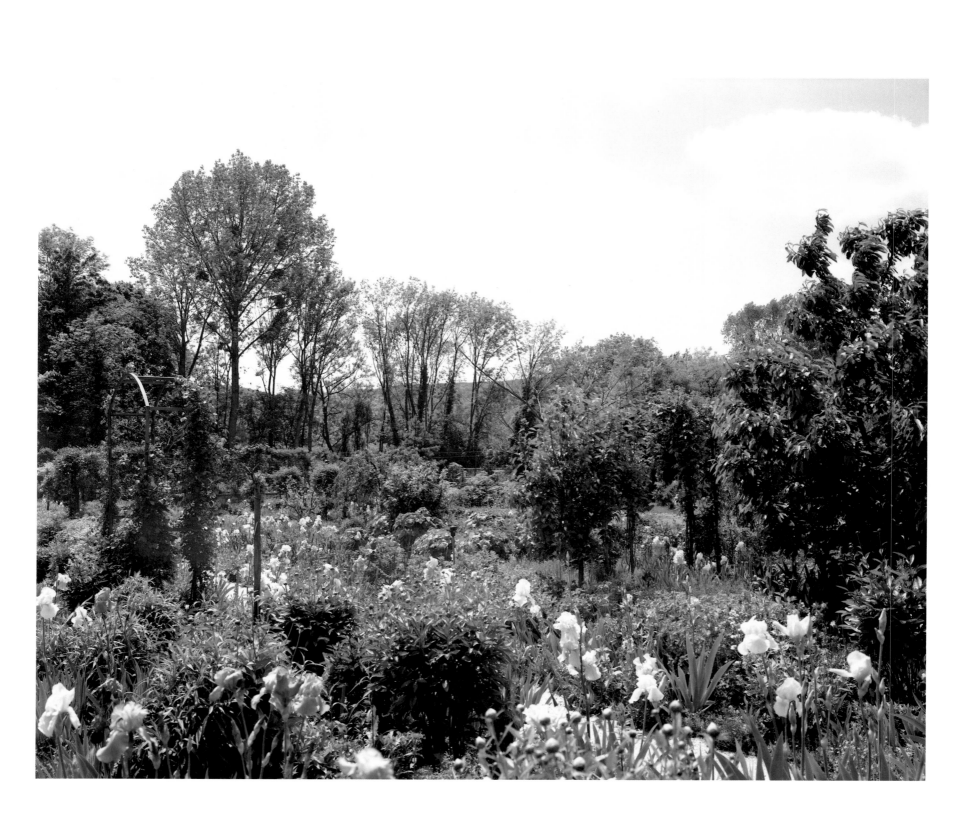

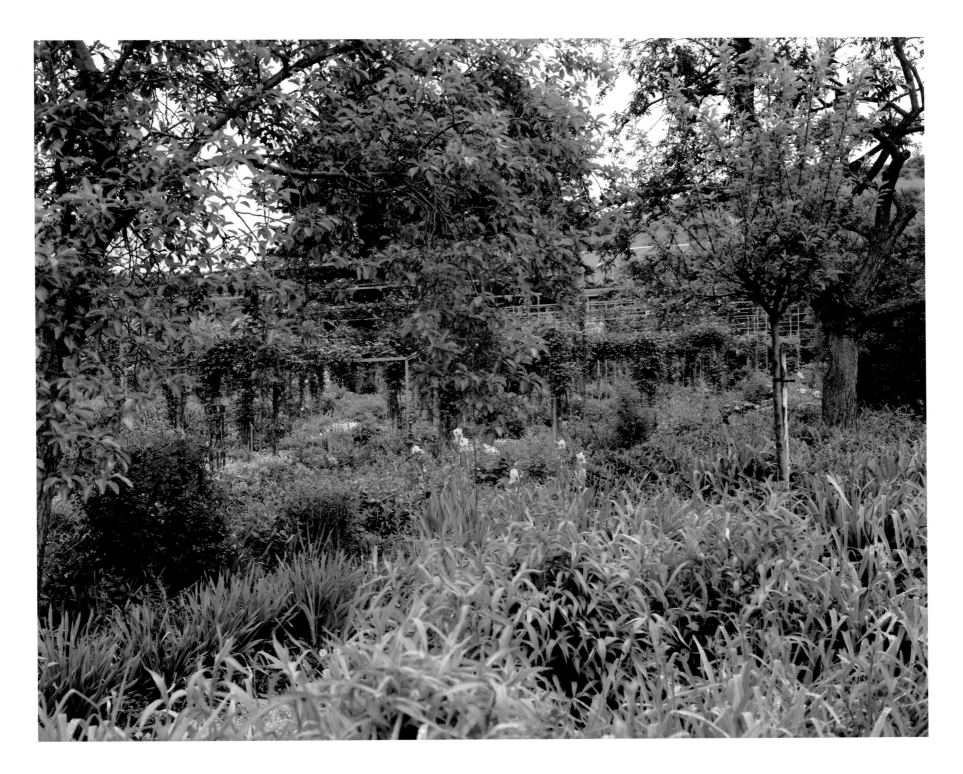

Wisteria, white and purple, continues to grow across the Japanese footbridge, just as Monet envisioned it (opposite and page 58). He often contemplated the view across the lily pond from a bench positioned at the edge (page 59), fascinated not only by the flowers and trees but by the reflections they formed, along with the sky and clouds, on the pond's surface. And he painted the bridge and pond in all seasons, at all times of day.

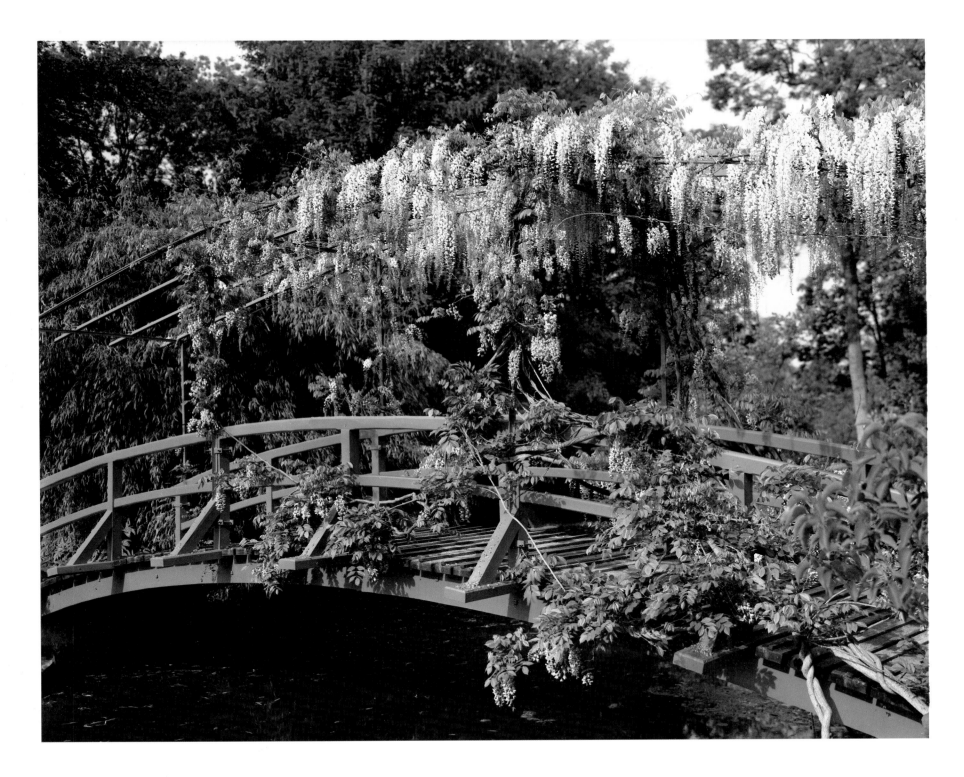

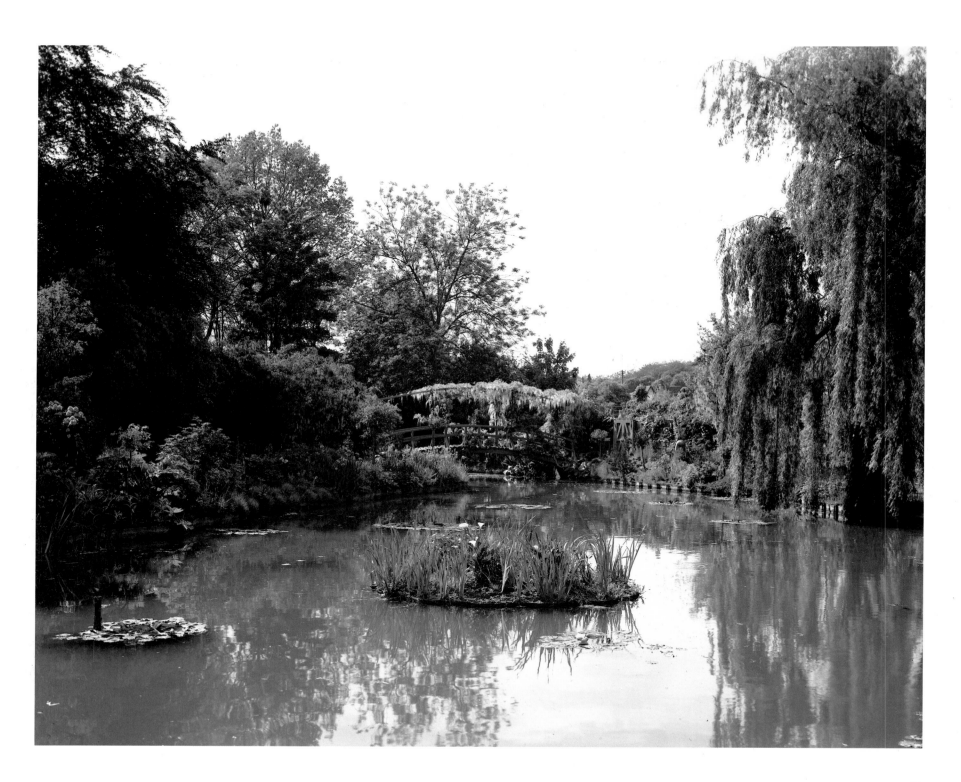

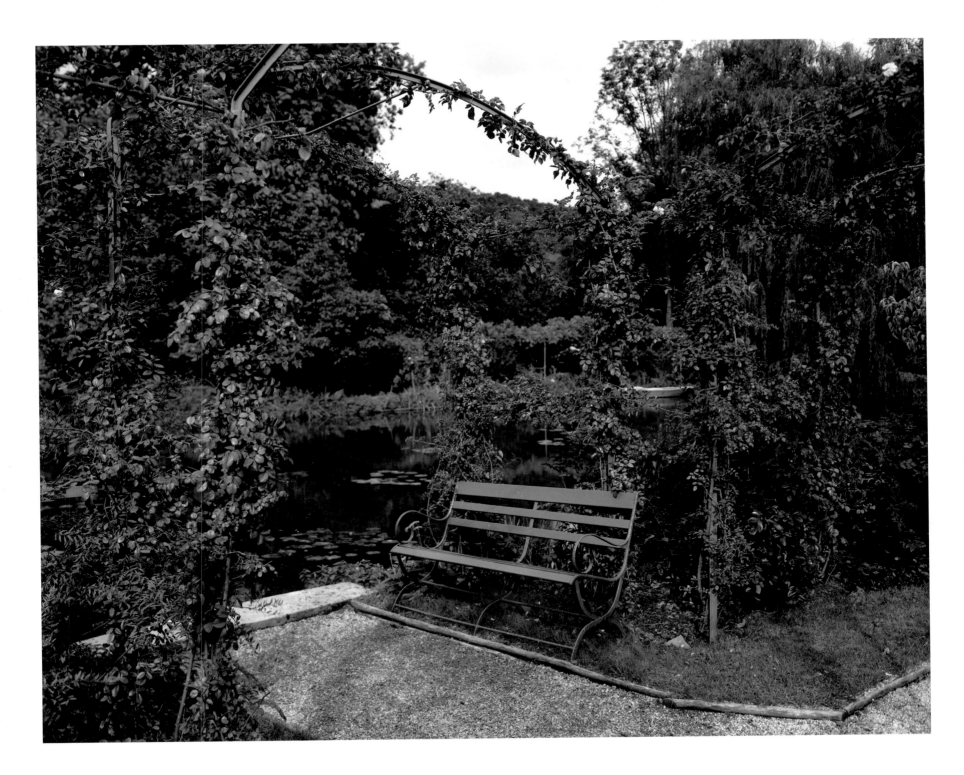

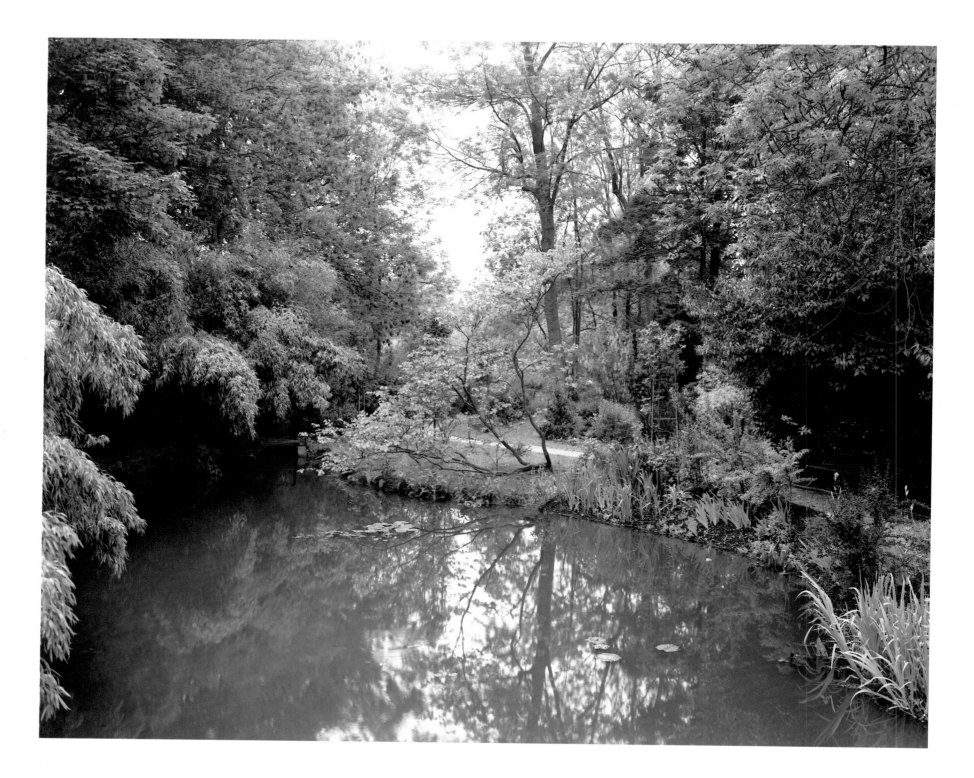

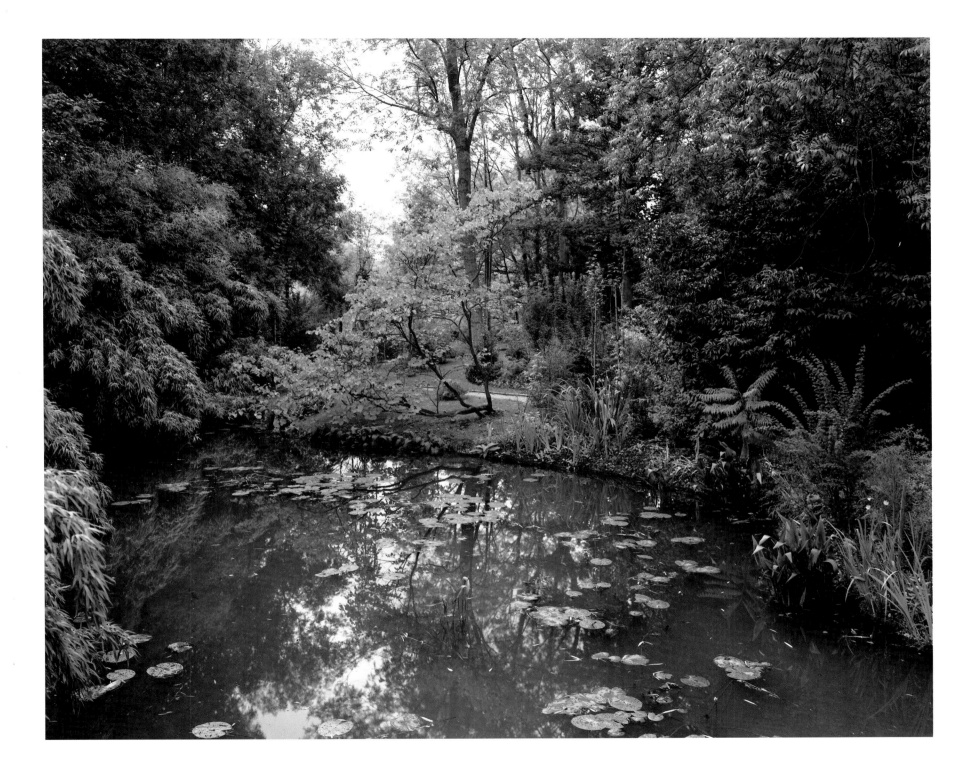

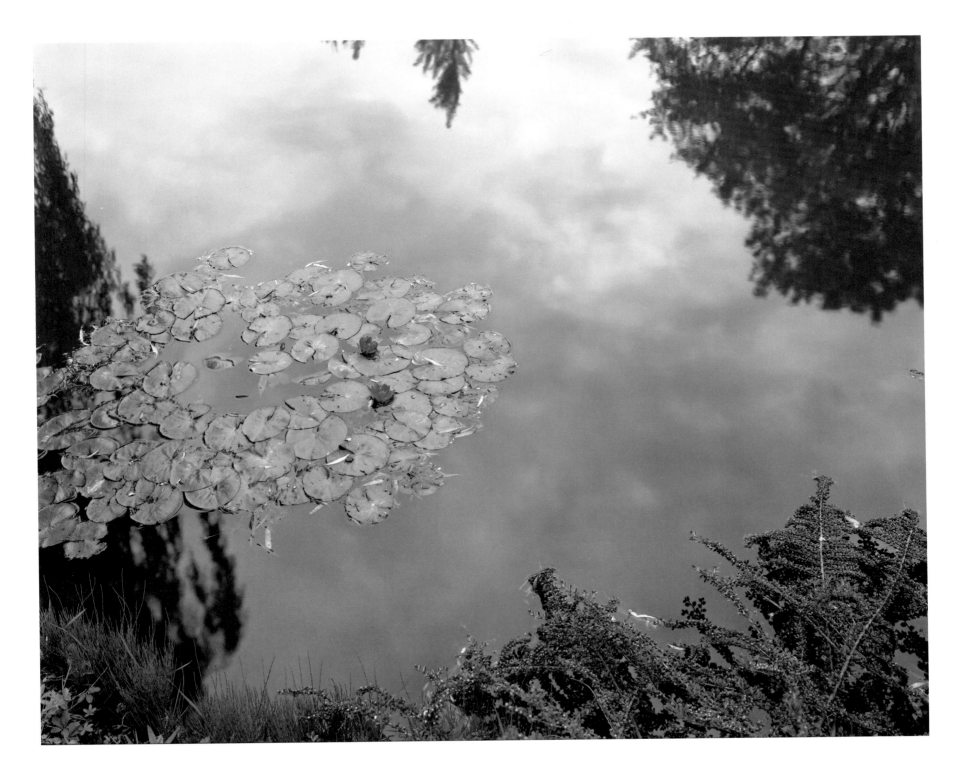

My garden is slow work, pursued with love,
and I do not deny that I am proud of it. *Claude Monet*

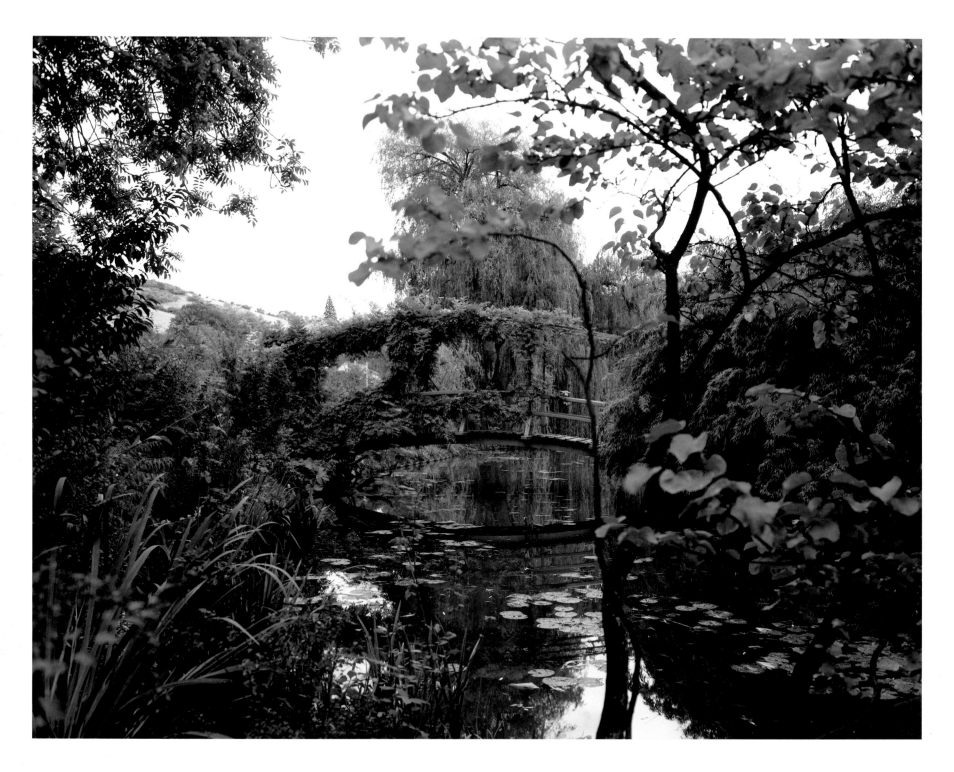

⧸⁓ I am happy to contribute to this book of beautiful works by a great photographer, inspired by the magnificent gardens of Giverny. With the sensitivity of a poet, Stephen Shore has given a new interpretation of this garden, which so enchanted Claude Monet and to which he gave all his care, attention, and love. Nothing meant so much to Monet: toward the end of his life he never spoke to his friends about his painting but always—and with what pride—about his garden! At the beginning of the century Monet's garden was already celebrated, and the few who were privileged to see it contemplated it religiously: this was a garden created by a great artist as a feast for the eye.

Monet's private garden has now become a public garden. It was my honor to have the distinguished mission of restoring it.

After Monet's death in 1926, the garden, along with the house in which he spent his last forty-three years, came into the possession of Michel, the artist's second son, but it was maintained by Blanche Hoschedé-Monet, his daughter-in-law. After Blanche's death in 1947, the house and garden were left to the care of an employee who gradually let the property decline.

Michel Monet died in a car accident in 1966 at age eighty-eight. In his will he left the house, the furniture, Monet's collection of Japanese prints, and all the artist's unsold canvases to the Académie des Beaux-Arts of the Institut de France. The architect Jacques Carlu, a member of the Institut, was entrusted with caring for the property. Carlu removed the paintings by Claude Monet and his friends, as well as the Japanese prints, to the Musée Marmottan in Paris. Beginning in 1971 the Giverny paintings, which had never before been seen by the general public, were exhibited with great success.

In 1977 the Institut asked me, as a member of the Académie, to attempt to save Giverny. Somewhat overwhelmed by the difficulty and the expense of the task, I nevertheless laid plans for the restoration, spurred by the knowledge that in all of France not one studio, residence, and property once belonging to a great artist remained intact.

The Académie and the Conseil Général of the department of the Eure assumed responsibility for the initial phases of the endeavor, but their resources were soon exhausted by the task of reviving the garden, which by this time was completely overgrown. Substantial funds were needed to continue with the plans. Many years earlier, my wife and I had created The Versailles Foundation in the United States, devoted to restoring and preserving the palace and grounds of the royal residence. We obtained permission from the United States Treasury to add the name of Giverny to the foundation. I found marvelous and generous friends of Claude Monet in the United States. Lila Acheson Wallace was the first to share my enthusiasm, and her generosity was the basis for the renaissance of the house and gardens. I thank her with all my heart.

When Monet moved to Giverny in 1883, the garden was basically a kitchen garden. Monet loved flowers—he had cultivated flower gardens at his earlier houses at Argenteuil and Vétheuil—and until 1892 he worked in the garden alone, helped only by the children, endeavoring to make it a masterpiece. As his financial situation improved, he hired a head gardener. Eventually he was able to employ five assistant gardeners, one of whom was responsible solely for the water-lily pond.

Monet planned the flower beds to bloom in continuous succession from spring to fall. As restored today the garden unfolds its beauties as it did in Monet's time. Beginning in late March the flowering trees spread a pink and white haze across the blue sky, while narcissus, tulips, forget-me-nots, and crocuses stretch out in a pleasing tapestry below. In May come the azaleas and the rhododendrons, followed by a sea of peonies, poppies, iris, and wisteria and veils of blue, white, and pink clematis supported by tall, rectangular trellises all along the edges of the garden. As these splendors fade, June brings an avalanche of roses in the garden and around the pond—rosebushes as well as climbing roses that cling to the trellises and arch over the central path. In the height of summer the intense colors of geraniums, dahlias, lilies, daisies, saxifrage, zinnias, and French marigolds set fire to the garden, and the pond sparkles beneath water lilies in bloom. In autumn the garden is gilded with sunflowers, black-eyed

Susans, and cannas harmonizing with the blues, the violets, the mauves of the asters, the blue-bells, and the delphiniums; the central path blazes with shades of yellow, orange, and vermilion; and the nasturtiums run wild. The overall effect is breathtaking.

In 1893 Monet bought land adjacent to his property which had a narrow creek filling a little pond bordering a small railway. (Unfortunately, the railway has since been replaced by a road so wide and dangerous that it was necessary to build an underground passageway connecting the garden and ponds.) After resolving various problems stirred up by the local peasants, Monet finally obtained permission to rechannel the creek (which feeds into the Epte River) and enlarge the pond. Like all painters of his generation, Monet was influenced by Japanese prints, and he designed his water garden in the Japanese style. He excavated the pond and reshaped its banks into irregular curves that give the impression of space and distance. He planted beautiful trees—maples, a purple beech, tamarinds, Judaea trees, Japanese cherry trees, weeping willows, a stand of bamboo—and shrubs—rhododendrons, azaleas, and a border of climbing roses. Along the edges of the pond he planted iris, agapanthus, butterburs, and peony plants as large as trees. Across the pond he built a Japanese footbridge, made famous by his paintings, and covered it with blue and white wisteria. In the pond, in the calm, shallow water, Monet planted all the varieties of water lilies that he would paint tirelessly until his death. The most beautiful of these canvases are the glory of the Musée de l'Orangerie in the Tuileries.

All this had to be recreated; some trees had died; the flowers and the water lilies no longer existed; the creek, polluted by various factories, had become black and oily; the pond was infested with muskrats.

Now, miraculously, the work and life of Claude Monet are a tangible presence in his garden. For those who wish to perfect their knowledge of the master's work, a pilgrimage to Monet's sanctuary at Giverny is essential. There Monet himself lives on.

GERALD VAN DER KEMP
Member of the Institut de France

∾ The age-old association between art and horticulture has given rise to both still lifes and garden scenes, each genre boasting its talented adherents. Claude Monet not only painted both still lifes and gardens but was also his own gardener. His friend Gustave Caillebotte was also a painter-gardener, but Caillebotte's garden no longer exists, while Monet's gardens have been exquisitely restored and have been open to the public since 1980. Credit for returning the gardens at Giverny to their original splendor belongs largely to Gérald Van der Kemp of the Institut de France and Lila Acheson Wallace, both of whom refused to allow this unique example of a garden created by a painter of genius for his own pleasure and inspiration to disappear.

When Monet settled in Giverny in 1883, the walled garden—conceived along grand lines by an anonymous predecessor—suggested to Monet a traditional setting to be modified in detail but retained in overall plan: a few flower beds in front of the house, to the east a small alley of linden trees pruned like those in schoolyards of the Third Republic, and—most important—the central path descending to the high wrought-iron fence along the road, bordered by two flower beds and a double row of evergreens. Though the flower beds remained as they were, the trees suffered various fates: two yews across from the house still stand today; the cypresses fell to the ax soon after Monet began to recreate the garden; and the Norway spruce, the romantic tree *par excellence,* later met the same end after a long battle between Monet and his second wife, Alice Hoschedé, who wished to save them.

At first the garden at Giverny made only an indirect contribution to Monet's work. By 1900 the garden began to play a dominant role, particularly the central path lined with nasturtiums, dahlias, asters, and other seasonal flowers. Each element brought its color, constantly changing with the play of light and shade, to the kaleidoscope of Impressionism.

Assisted at first by his two sons and by the children of Alice Hoschedé, Monet soon had at his disposition a small army of gardeners faithfully executing his instructions. According to the unpublished recollections of the journalist H. Ciolkowski, "Their whole art consisted of caring for the garden seemingly effortlessly, giving Monet the impression of semi-abandon, of total freedom, under his rigorous surveillance. He was very strict, and I saw him flush with anger when an order was not carried out."

The artist lavished particular attention on the water garden, purchasing a field adjacent to his property and designing a pond surrounded by beautiful trees to harmonize with the neighboring countryside. The water garden reveals Monet's taste for flowing contours, which he used freely to outline the banks of the pond. This pond is bordered by willows and aquatic plants (especially iris *Kaempferi*) and is full of native white, as well as exotic colored, water lilies. With the pond Monet paid homage to the curves of Art Nouveau. The pond also allowed the artist—his vision increasingly blurred by cataracts—to explore the realm of abstraction. Many contemporary painters salute Monet as a forefather of modern art.

Most European countries—particularly Italy, which can claim the admirable gardens of the Villa d'Este at Tivoli—have offered horticultural subjects worthy of artistic attention, but painters have largely shunned compositions featuring well-known parks and gardens. Hubert Robert's sketches of the park at Méréville—since divided into lots—remain isolated examples. Even when artists have yielded to temptation and painted man's collaborations with nature, they seldom stooped to collaborate themselves: the olive and orange trees of Les Collettes preceded Renoir's arrival at Cagnes, and the gardens of Auvers owe nothing to Vincent van Gogh. But Monet himself cultivated and embellished the walled garden of Giverny and planned and supervised the construction of the water garden. For a quarter century, the two gardens constituted his major, and soon his only, source of inspiration. The pink house with green shutters overlooking the gardens was home to the master for over forty years until his death in 1926. The genesis of Monet's late masterpieces, his water-lily paintings, cannot be understood outside the boundaries of Giverny, where the lilies have now been preserved from the reaches of man and from the ravages of time.

May all those who wish evidence of Monet's great enterprise find, in this magnificent album of photographs by Stephen Shore, a pleasure comparable to that which we have enjoyed in preserving the gardens at Giverny.

DANIEL WILDENSTEIN
Member of the Institut de France